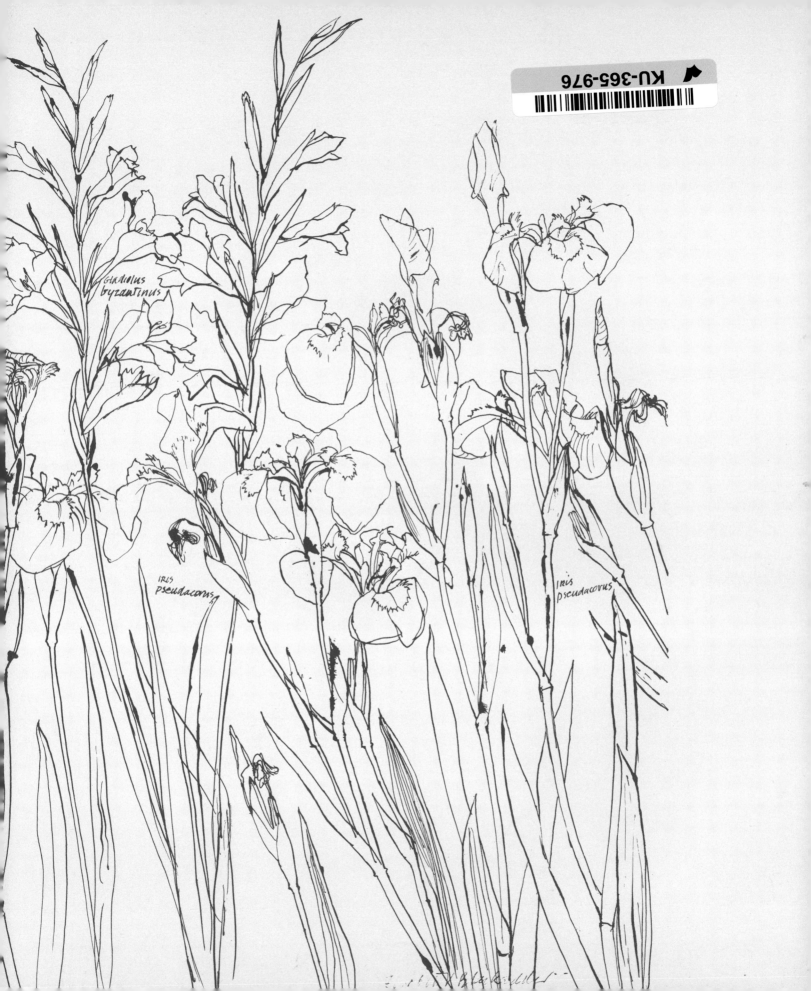

. . . Elizabeth Blackadder. . .

. . . *Elizabeth Blackadder* . . .

DUNCAN MACMILLAN

Scolar Press

Published by
Scolar Press
Gower House
Croft Road
Aldershot
Hants GU11 3HR
England

Ashgate Publishing Company
Old Post Road
Brookfield
Vermont
05036-9704
USA

First published 1999

British Library Cataloguing in Publication Data
A CIP record of this book is available from the British Library

A limited edition of 100 copies, in a slipcase, contains
an original coloured etching *The Lily*.
Each copy of the book and etching is signed and numbered by the artist.

Standard edition ISBN 0 7546 0063 7
Limited edition ISBN 1 84014 669 9

Produced for the publisher by
John Taylor Book Ventures, Faringdon, Oxfordshire
Designed and typeset by Peter and Alison Guy
Printed in Singapore

. . . Contents . . .

Elizabeth Blackadder	8
Childhood and Student Years	9
Marriage	15
Early Travels in Europe	16
Early Printmaking	25
Paintings of the 1950s and 1960s	26
The Mercury Gallery	40
Paintings of the 1970s	46
Flowers, Gardens and Cats	49
Japanese Paper: a new departure	72
Journeys to Japan	78
Printmaking in Glasgow	82
Depth, Surface and Reflections	91
A Return to Oil Painting	101
List of Plates	120
Chronology	122
Selected Bibliography	123
Solo Exhibitions	126
Selected Group Exhibitions	127
Works in Public Collections	128
Photographic credits	128

. . . Elizabeth Blackadder . . .

ELIZABETH BLACKADDER works in several different modes, but to say so is not just to comment on the practical differences between oil painting, watercolour, drawing, and the various techniques of printmaking that she has used over the years. Her work is always immediately recognisable in all of these, but flowers, still-lifes, landscapes, and even her occasional portraits all elicit a slightly different response from her. To use a musical analogy, perhaps this is no more than a difference in key, or to extend the analogy maybe the difference between music for orchestra, chamber group, or solo instrument. As with any composer there are exchanges between these categories, but much more importantly there is also a deep underlying consistency. It may be that the apparent diversity of her output has obscured this unduly, but in recent years this consistency has grown more striking as her work in these different modes has converged. As this has happened, the common concerns that unite them as well as the constant exchanges between them have grown more apparent and so perhaps we can now form a clearer estimate of her status as an artist than we could before.

Her brilliant flower paintings in watercolour, though they are only one part of a rich and diverse artistic output, will serve as a witness to things that are central to it all. For an artist can approach the business of painting a flower in many different ways. They range from the meticulous enumeration of its details that is appropriate to the botanist to the summary invocation of shape and colour of the expressionist, for whom the flower itself is no more than an opportunity for a display of feeling. Elizabeth Blackadder's sensitive affection for the beauty of the created world and her respect for the individual nature of the flower lead her to give an account of its appearance thorough enough to satisfy the demands of any botanist, but though she never strays in the direction of expressionism, nevertheless these are very clearly paintings, not scientific analyses. Irises rocketing skywards, tulips spreading their petals, voluptuous as courtesans, orchids growing in patterns purposeful and complex as a spider's web, she observes and records them all in a way that is unique in its combination of sharpness of observation with manifest sympathy, a kind of imaginative projection which, because of her skill, we can share.

In these watercolours the marks that she makes with her brush are natural, open and unforced. Her gift lies in finding the equivalence between this easy movement of her hand and the forms of the things she wants to describe. It is in fact a wholly intuitive way of painting. Even though it is governed by such disciplined precision, there is a swiftness and fluency about it that goes much deeper than description to express her sympathy with the energy that flows through all living things: 'The force that through the green fuse drives the flower' (Dylan Thomas). And if this is true of her flower painting, it is equally true of all her painting. For it is always intuitive. Its subject matter is taken from the world around her: things close

to her, places she has been, the flowers in her garden. It reflects her imaginative projection into them, the sympathy that expresses her sense of community with them, not just as a sentiment, but as part of a coherent artistic vision.

And returning to those flower paintings again for a moment, they have another important characteristic that reflects this and is indicative of her whole approach to painting. For her a flower painted on a page is not a specimen pinned to a neutral support. The paper on which the image sits is as much part of the picture as the image itself. It is active not passive. So the placing of the image, the spaces around it, are of vital importance and are carefully considered. They reflect this same extension of sympathy. Everything exists in a context; space, time, our perceptions are all indissolubly linked. So this linkage, this context is part of any image and here she has found support in recent years for her point of view in the Far East, particularly Japan. Though this is also a concern which, as we shall see, places her into the mainstream of modern painting.

But she could not do this if her art was not already firmly based in the grammar, the syntax of Western painting. For to express her feeling about the thing beyond herself but which she describes, she has to start from the same, intuitive understanding and sympathy with her vehicle, with her medium: paint, paper, canvas, ink, etching, lithography, whatever else. The marks, the support, the spaces between things, all these are considered not as tools, but as things in themselves and it is the communion between that immediate, practical feeling expressed in the process and its extension into the subject that is the special alchemy of her art.

And if this is true of her art now, it always has been. It has evolved and many factors have played a part in that evolution, but she has been consistent in this central aspect of it and so that in turn points not only to the special nature of her gifts, and the depth of her reflection on the business of painting, but also to the environment in which her art has flourished. The factors that make up the habitat in which a plant will blossom are complex and some of the most beautiful are the most exacting in their requirements. It is the same with art. The delicacy and beauty of Elizabeth Blackadder's painting reflects the special characteristics of the environment in which it was nurtured.

. . . *Childhood and Student Years* . . .

To say that is not in any way to diminish her originality, only to suggest that fully to understand it, one has to see it framed in the wider artistic environment of which it is such a conspicuous ornament; and that takes us back to consider the community of painters who flourished in Scotland in the middle decades of the twentieth century, who flourished and who also taught. For the tradition of painting in Scotland has for a long time been maintained by the exchange between the generations of teacher and pupil in the four art schools. Among them, Edinburgh College of Art was a specially fertile place at the time when Elizabeth Blackadder first studied and then taught there. At the time that she was a student (she arrived at the Col-

lege in 1949) many of the first generations of artists trained there had come back to teach and they brought the College to what was certainly the best and most influential period in its history up till now. Chief among them was William Gillies. From student to Principal, he was connected to the College for most of his life; but in this story Penelope Beaton who actually taught Gillies also plays an important role and so does Robert Henderson Blyth. He had studied at Glasgow, but in his third year he had gone to Hospitalfield in Arbroath, then a summer school run jointly by the four art schools. James Cowie was in charge. Henderson Blyth came under his spell and never completed his Diploma. Nevertheless after serving in the war he was appointed to teach at Edinburgh.

Outside the College too this was an environment in which several women artists had established themselves as leaders. Not only Penelope Beaton who taught, encouraged and befriended Elizabeth, but Anne Redpath and Joan Eardley were producing and exhibiting some of their best work at just the moment she was launching her career. Anne Redpath was a College governor and Elizabeth remembers meeting her for the first time when she was awarded a postgraduate scholarship in 1954. Later they were neighbours and she got to know Joan Eardley well, too, and though she died in 1963 when Elizabeth was only starting her career, it seems to have been a relationship of mutual respect. Elizabeth married John Houston in 1956 and their friendship with Joan Eardley was warm enough for the older painter to stay with the young couple when she came to Edinburgh to hang the annual Scottish Society of Artists exhibition a year or two later.

Looking back on them now, men and women, we can see clearly how the best painters in this generation shared a clearly expressed and powerful set of convictions. Their subject matter is the world of experience rendered above all in still-life and landscape. Their approach is free, but it was important that for most of them that freedom stopped short of expressionism where the balance is tipped away from the sympathy extended outwards which informs the art of the best of them, and leans instead towards the artist's own inward-turning self-expression, ultimately a difficult road to travel. On the other hand their art is certainly endowed with feeling. It is intuitive, neither intellectual, nor theoretical, but in many of them their dedication to it was so intense it was almost monastic, setting a standard of the deepest professional commitment to the younger generation.

Elizabeth Blackadder joined this milieu when she came to Edinburgh as a student. Perhaps her background had already prepared her to respond to it as wholeheartedly as she did. It is useless to speculate about genetic inheritance, but, though he died when she was only ten, the fact that her father Thomas Blackadder was an engineer descended from a long line of engineers is surely relevant. Her brother, five years her senior, went on to become an engineer in turn, so the tradition was strong. Much of the work was routine, maintaining the machinery at the local brewery and printing works, for instance, but there was inevitably design involved as well and the home environment she describes from those early years is one in which visual thinking, and the apparatus of drawing and model-making that were its expression, were an accepted part of life. Her father was also a serious

photographer with his own darkroom and all the paraphernalia of photography. Such an atmosphere could be just as stimulating as a background that was more conventionally 'arty'.

Her father's father, also Thomas Blackadder, was a marine engineer and the family firm, founded in 1851 by his grandfather in turn, was Blackadder Brothers Garrison Foundry and Engine Works in Falkirk, the town where Elizabeth was born. The strength of Scottish engineering in which Falkirk played such a distinguished part had always been the way in which it was in practice as much a visual profession as a scientific one. Engineering involves drawing as the vehicle for the projection of thought – ideas extended in space. It is also a field where precision is allied to elegance and economy of thought in the solution of problems. The satisfaction that the engineer takes in his work is often purely aesthetic. One should remember here that Alexander Nasmyth, 'the father of Scottish landscape' as David Wilkie called him, and from whom therefore Elizabeth is also descended in one line of her artistic heritage, was a successful engineer as well as a painter. He designed bridges, drew the designs for one of the world's first successful steamships, Patrick Miller's ship that sailed on Dalswinton Lock in 1788. He devised the first shaft-driven propeller and the compression rivet. Thus he fundamentally influenced the history of ship design, the chosen discipline of Elizabeth's grandfather. Nasmyth also shared his passion for marine engineering with his close friend Raeburn. Such information is more than merely tangential, too, for Elizabeth's own forebears had a hand in designing another of the first steamships, the Charlotte Dundas, and engineering drawings for the vessel have remained in the family.

If the business of designing and the equipment for drawing and model-making were part of Elizabeth's childhood, so too was collecting. Her grandfather was a great traveller and as he travelled he also collected. His house in which she was born and spent her childhood was full of his collections, not of art necessarily, but of all kinds of miscellaneous and exotic things from around the world in a way that her own house still is now and which is certainly reflected in her painting. Indeed it has shaped her art. Her still-life paintings from early on, but especially those magical still-lifes on Japanese paper that have been a feature of her work for many years, are really just that, collections of treasured objects held up for contemplation. So with its collection, her grandfather's house and childhood home was a memorable place, its memory still reflected in her art. More mundanely, as befit ted an engineer, it was also the first house in Falkirk to have central heating and Elizabeth remembers how as children she and her brother, Thomas, had to stoke the boiler in the basement.

There were of course other things in her childhood that by her own account helped to shape the artist she has become. She spent a significant part of her childhood on the West Coast staying with her maternal grandmother at Kilmun on the shores of the Holy Loch, both on summer visits and for an extended period during the war when she went to primary school at Strone and for a while, too, to Dunoon Grammar School. In her grandmother's house she was much on her own, but in an environment that was ideally suited to stimulate an imaginative and

inquisitive child. Her love of botany dates from these early years and in the various houses she frequented there were plenty of books in which she says she read widely, if not always suitably. From an early date too botany was linked in her mind with art as she drew the flowers and plants she collected.

The home of her childhood was also typically Scottish in the way that the value of education was unquestioned. Her mother had pursued her own education with determination and so was there to support her daughter's ambitions. There seems to have been no debate about whether Elizabeth went on to higher education, only about what she should study. She recalls now that she was for a time undecided between art and science. She was particularly drawn by her love of botany, but by the time she reached the sixth year she had gravitated decisively to art. She was fortunate at school to encounter imaginative and stimulating teaching in her art classes with the art master James Scott, and also encouragement from the school's rector, A.C. MacKenzie, clearly an imaginative man and also a lively and impressive interpreter of literature. Certainly she found none of the prejudice against art as a career for a bright pupil that still prevails in too many schools. Discussing the way she was encouraged she remembers that she was also aware of others who had gone recently from similar backgrounds to study art and become artists. A cousin, Ian Blackadder, had gone to art school and from nearby Grangemouth Alan Davie had gone to Edinburgh College of Art.

If there was any lingering suspicion of art schools as not quite respectable edu - cationally, the new Fine Art Degree at Edinburgh University provided the answer to such doubts. A family friend, Professor T. Ferguson, Professor of Public Health at Glasgow University, found out for her about this new course which had been set up just after the war on the initiative of David Talbot Rice, Professor of Fine Art at Edinburgh University. It was a cooperative undertaking between the University and Edinburgh College of Art. The Fine Art Department of the University was then housed in an old church (now the Bedlam Theatre) at the end of George IV Bridge. The College of Art was a few hundred yards down the road at the far end of Lauriston Place. Nor was this degree an entirely new departure. Talbot Rice was Watson Gordon Professor of Fine Art and the chair had been established in memory of the portrait painter, Sir John Watson Gordon, in 1879 as a joint project between the University and the Royal Scottish Academy with the purpose of teaching art history to students at the Academy alongside University undergraduates. This arrangement survived the creation of Edinburgh College of Art, which inherited the teaching functions of the Academy, and College students continued to have access to the University till the creation of the new Fine Art Degree for which Elizabeth now enrolled and which in effect extended this exchange into a full degree for a select group of students and combined studio work and art history in equal measure over a five year course.

David Talbot Rice and Giles Robertson who joined him in the Fine Art Department just after the war were both men of wide culture and real commitment, not just to art history as an academic subject, but to the visual arts as a living thing. Although as a scholar he was a Byzantinist, Talbot Rice took very seriously the

dedication of his chair to the practice of the visual arts. He was on friendly terms with most of the leading Scottish artists, so many of whom taught at the College of Art, and started a collection of their work in the University. Nevertheless, although relations were close and friendly, for practical reasons the relationship between the two parts of the Fine Art Degree as the students experienced it was often difficult. Elizabeth herself at one point nearly abandoned the joint course in favour of the studio alone, but she stayed the course and it surely gave her the best possible start for the career she was to follow.

If the College led by Gillies was resolutely anti-theoretical, under David Talbot Rice's leadership the University course balanced this, not with theory (indeed he deliberately avoided any competition with the College by avoiding any in depth teaching of modern art history), but with a powerful sense of the way in which the art of the present is continuous with that of the past and, too, how it is rooted in much wider cultural values. But the teaching at the University complemented that at the College in others ways too. Following the English formalist theory of art expounded by critics such as Roger Fry, Clive Bell and Bernard Berenson, the painting of the Italian Renaissance in the fourteenth and fifteenth centuries, of Giotto, Masaccio and Piero della Francesca, was widely accepted in the art schools of the time as the supreme model of great painting. This was of course also the central topic of art history. In Edinburgh the Italian Renaissance was Giles Robertson's great enthusiasm, especially the painting of Quattrocento Venice, but David Talbot Rice's own enthusiasm for Byzantine art perhaps also sprang from the same source. Clive Bell specifically identified the hieratic simplicity of Byzantine art with this kind of formalism and Talbot Rice's own interest in Byzantine art was formed at Oxford when this approach to art was at its most fashionable.

But if he did not teach it directly, Talbot Rice did not ignore modern art. Elizabeth remembers when she was a young student handling paintings by Picasso and Matisse. In 1949 and 1950 Talbot Rice arranged for the student art society to borrow works by these and other artists from his London friends and from dealers such as Reid and Lefevre. These modern works were put on exhibition in the University Library. The catalogues survive. In May 1949, just before Elizabeth began her studies, the exhibition was of modern British painting, works by almost all the major figures of contemporary British art. But in May 1950, that is during Elizabeth's first year, the exhibition included works by Braque, Derain, Léger, Matisse, Picasso, Rouault, de Segonzac and Vlaminck. Some were works on paper certainly, but there was also a *Landscape at L'Estaque* by Braque from 1908, borrowed from Douglas Cooper, and Picasso's *Mandolin and Apples* borrowed from Ronald Penrose, together with drawings by Picasso ranging from 1905 to 1914, Léger's *Les Toits de Paris* from 1912, also from Douglas Cooper, and Derain's great *Blackfriars* of 1907 from Glasgow. Together they constituted as vivid an introduction to the early history of modernism as you could wish, and brought to the students with all the added imaginative impact of hands-on experience.

The impact of such experiences should also be set in the context of a world not yet bombarded with images as it is now. There were no glossy illustrated cata-

logues and relatively few art books. What could be seen at first hand was correspondingly more important. Conscious of this perhaps, the Scottish Society of Artists had been quick to work to restore contacts with the Continent after the war, showing contemporary French painting in 1945, and, still at the time a bold thing to do, showing a big collection of German Expressionists in 1950. In 1951 the Arts Council organised a comprehensive exhibition of contemporary English painting, followed in 1952 by more than fifty young artists from France, including such names as Alfred Singier, Pierre Tal Coat, Bernard Buffet, Georges Mathieu, Hans Hartung and Pierre Soulages, together with the Danish artist Richard Mortensen, the French-Canadian Jean-Paul Riopelle, and many others, all shown in an exhibition *Young Painters: École de Paris*. A group of the painters came to Edinburgh and Elizabeth remembers them visiting the studios at the College of Art. This exhibition was followed too by major exhibitions in successive years at the Edinburgh Festival of Renoir, Cézanne, Gauguin and Monet. Nicolas de Stael was shown at the Scottish Society of Artists in 1956. In 1958 the Moltzau Collection, which was principally of School of Paris painting, was shown at the Festival. Also of particular importance to Elizabeth was the exhibition at the Royal Scottish Academy in 1955 of the Estorick collection of modern Italian painting.

Altogether there was plenty to see and stimulate a young artist's imagination, but this was of course also against the background of the College environment where teaching was still a direct and engaged process in an atmosphere of discipline. You would never dare be late for a class, recalls Elizabeth. But this formality was backed up by a powerful and pervasive professional example. Gillies, for instance, who was head of painting when Elizabeth began, was scarcely loquacious, but conveyed an almost tangible sense of commitment. Gillies' friends and contemporaries John Maxwell and William MacTaggart also both taught at the College. Though Maxwell who came and went several times was not there during the same years as Elizabeth, he had a great reputation and MacTaggart, though he only taught part-time, Elizabeth remembers with affection.

But Penelope Beaton and Robert Henderson Blyth are the two teachers whom she remembers with a real feeling of indebtedness as well as friendship. Penelope Beaton she recalls as at first an immensely tall and commanding figure and a stern teacher. Nevertheless she took a warm interest in her students and encouraged them, not just in their work, but as they launched themselves into the professional world too. It was on her prompting that Elizabeth first plucked up the courage to send work into the Scottish Society of Artists and Royal Scottish Society of Painters in Watercolour in 1955 and so to begin her exhibiting career.

Robin Philipson started teaching at the College only shortly before Elizabeth began there. He taught her in her second year and she recalls him as a flamboyant figure from the start. Perhaps she related more closely to the quieter and more reticent among her teachers, but of course she remained a friend and colleague of Philipson till the end of his life; and though his work developed differently, her early work does offer parallels to his, especially in her landscape painting. Henderson Blyth, also still in his early thirties and who like Philipson had only started

teaching at the College after he had completed his war service, left Edinburgh for Aberdeen in 1954, Elizabeth's penultimate year, but they remained close friends till his death in 1970 and some of her paintings of the North East coast were done when staying with him in his new home in Aberdeen. Henderson Blyth was profoundly influenced by his time with James Cowie at Hospitalfield and Cowie, a little older, was a very different figure in Scottish painting from Gillies and the Edinburgh painters. He was a great draughtsman. Not exactly a theorist, he nevertheless had very decided views and was a very literate and articulate champion of the complex possibilities of art. Perhaps through Henderson Blyth, Cowie's indirect influence was for Elizabeth an antidote to the slide into facile subjectivity that might so easily have followed the purely intuitive approach to painting of the older Edinburgh painters.

. . . Marriage . . .

As well as these personal contacts, the work of these and others she knew professionally was on show every year in the Academy and elsewhere. Gillies especially exhibited indefatigably. In the years Elizabeth was a student he held one-man shows in Edinburgh in 1949, 1950, 1952 and 1953 as well as participating in group shows also in Edinburgh in 1951, 1952 and 1954. It is not surprising that he has had such an enduring influence on her work. But in any student group the first and most intense interaction is with one's peers; the immediate environment is one's own generation. Among her contemporaries in the Fine Art Degree was Mary Taubman, who worked as portrait painter and later wrote on Gwen John. At the College, John Houston was a year ahead of her though she actually graduated two years after him. The Fine Art Degree in which she was enrolled was a five-year course, as opposed to the four years of the College Diploma. They married in August 1956 and by that time he was on the teaching staff. Among John's contemporaries were David Michie, Frances Walker and David McLure.

Elizabeth graduated in 1954. She had written her final year thesis on William McTaggart, grandfather of her teacher of the same name and the greatest Scottish landscape painter of the nineteenth century. She had been impressed by an exhibition of McTaggart's work in the Diploma Galleries of the RSA which included the remarkable group of works that had been collected by John W. Blyth and that are now in the Kirkcaldy Art Gallery. Her thesis was a substantial piece of research. It entailed producing a text some ten thousand words in length and it was at that date also an original choice of subject. It caused a little concern among her tutors as being perhaps too 'modern' and it did not have at first sight an obvious bearing on her own development as a painter, except in a general sense that McTaggart was a great figure in the Scottish landscape tradition with which she was already beginning to identify herself. But perhaps her choice also had a deeper significance. Within that tradition McTaggart clearly stands for the sympathetic identification of the artist with his subject matter, the search to express a kind of imaginative empathy. You see this still in Gillies' best paintings, his landscapes in the Lammer-

muirs, or his watercolours of the West Coast from the 1930s, for instance; and it is for this reason that it is not far-fetched to identify Joan Eardley's great sea paintings of the late 1950s and early 19960s, not only with de Staël or de Kooning among her contemporaries, but also back in time with McTaggart. Perhaps in this choice, therefore, instinctively, for it could hardly have been otherwise, Elizabeth was already declaring an allegiance to the tradition whose flag she has carried with such distinction ever since.

. . . *Early Travels in Europe* . . .

A number of works survive from her student days. Among them some powerful life drawing, an elegant self-portrait, just the head, a dark painting of a dredger working on the Forth-Clyde Canal. This latter was exhibited in 1955 but painted in 1953. But the first substantial body of work that survives derives from the two periods she spent travelling in 1954 and 1955-6. The first was with a Carnegie Scholarship when, after she graduated, she went by train to Venice and thence to Yugoslavia and Greece in the summer of 1954. John accompanied her. The principal objective was to see the Byzantine churches and mosaics that she had studied with David Talbot Rice. Travel was still quite difficult and they had limited success in their precise objectives, but there can be little doubt of the imaginative impact that the trip had on her. They went out to Greece through Yugoslavia, in Greece going first to Salonica and then Athens, and they returned through Italy via Brindisi. This route gave her the chance to go to Rome and Ravenna for the first time and there, if not in Greece, her belief in the grandeur of Byzantine art was confirmed.

Some of the works survive that she produced during this trip, or that she painted afterwards on the basis of notes and records made in the sketchbook that she carried with her all the time, and a number of these works were exhibited in 1955 at Gimpel Fils in an exhibition chosen by Peter Gimpel from student work from colleges throughout England and Scotland and called *Eight Young Contemporaries*. Among them a watercolour of a church in Salonica looks forward to the mood of Elizabeth's later work as she captures the luminous blue of an open veranda built against a sombre brown church (*Church in Salonica*, Plate 1). Mostly, however, these paintings are dark and sombre. A little church at Aegina, for instance, though it is also the subject of a light and airy watercolour done on the spot, was later turned into an intense, dark oil painting. The church is grey-white in heavy impasto; a figure on a mule is no more than a sinister black shadow in the foreground. Another large and ambitious composition has a similarly sinister feeling to it. It is a strange image of rural alienation. Two figures on mules, a man and a woman, pass each other in the foreground. The woman is shrouded in black. The man's face is a mask. His mule is painted an almost flat, dark red. Though they are close there is no apparent contact between them, and this psychological distance is emphasised by the bare and empty landscape that stretches behind them up to a group of grey-white houses on a hill above.

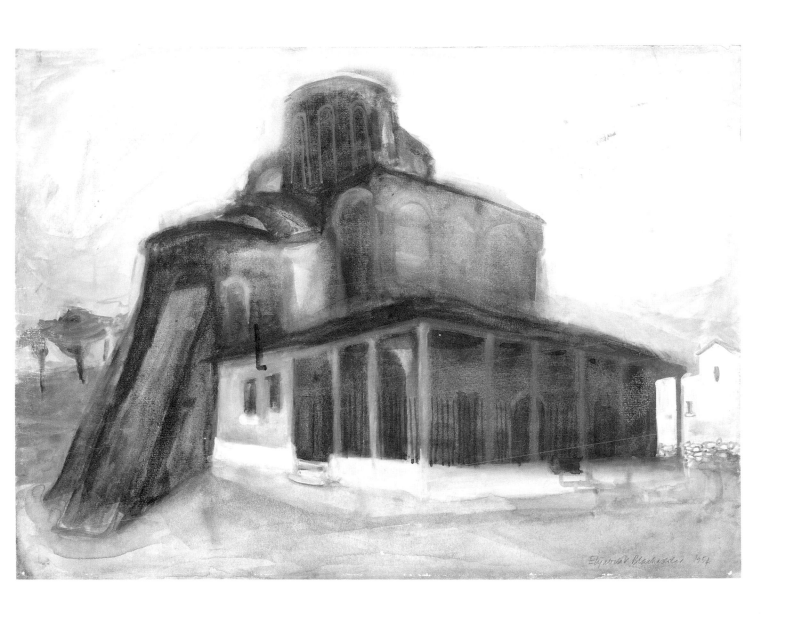

1 *Church in Salonica*
1954 Watercolour 15 x 20 in (38 x 51 cm)

After her graduation Elizabeth was awarded a postgraduate scholarship by the College for the year 1954-5. She remembers that the paintings which were exhibited at Gimpel Fils in 1955 were painted during that postgraduate year, though the *Dredger* which she also exhibited was painted even earlier. It is all in greys and earth colours. A little Indian red is the strongest tint. Partly this extreme limitation of colour was the teaching; she remembers an exercise to paint a picture in no more than three colours; but partly it was the mood among her contemporaries. She looked to the dark paintings of Italians like Sironi, Morandi and Gentilini. She saw their work reproduced in the architectural magazine *Domus*, and books on these and other contemporary Italians acquired by the College Library were among the rare, contemporary publications of the kind available there. She also remembers buying a book on Sironi for herself and those mask-like faces in her painting of Aegina certainly reveal an affinity with his work. This dark, subdued kind of painting was also partly a reaction against those in the older generation who had followed John Maxwell into a romantic and poetic, but rather inward-looking kind of art. The gritty, black and white world of contemporary cinema, of de Sica's *Bicycle Thieves*, for instance, or Rosselini's *Open City*, was closer to the artistic mood of Elizabeth, John Houston, David Michie, David McLure and Frances Walker who all painted sombre, social realist pictures around this time. In this spirit Elizabeth could rarely have painted more blackly than she did in a surviving painting of Leith Harbour: black buildings over black water, a black boat in the foreground barely distinguishable in the gloom.

A second period of travel followed this postgraduate year when in the summer of 1955 she was awarded a travelling scholarship, a substantial award that enabled her to spend nine months in Italy. John, who had spent his own travelling year in Italy two years before in company with David Michie and so knew his way around, accompanied her there in July, but in September he left her in Florence as he had to return to teach. She stayed on for the whole of the winter of 1955-6, most of the time on her own, though for a while she had the company of John Busby and the luxury of his car.

She remained based in Florence, staying in the Via Serragli near the Porta Romana. She went regularly on the bus out into the Tuscan countryside, or travelled down to Prato, Pistoia, Pisa and Lucca. But she also went on longer trips to Siena, Arezzo, Venice, Ravenna and Milan. She worked constantly, out of doors during the day, back in the *pensione* at night. A beautiful, sympathetic drawing of Gina, niece of the owner of the *pensione*, records some of the company she kept. She had to learn Italian for there was no other conversation available to her and she and Gina used to go together to the cinema occasionally.

Conditions were not easy, but she produced a large body of work, all on paper, in drawing and watercolour. She did not have oil paint with her, nor did she have a studio where she could have used it. The mood of her art did not lighten and her landscapes are stark and wintry: bare trees, cold hills. *Winter Landscape at Assisi* (1955, Plate 2) for instance, or *Tuscan Landscape*, both painted in grey washes of gouache and chinese white with only a hint of warmth and with little incidents of

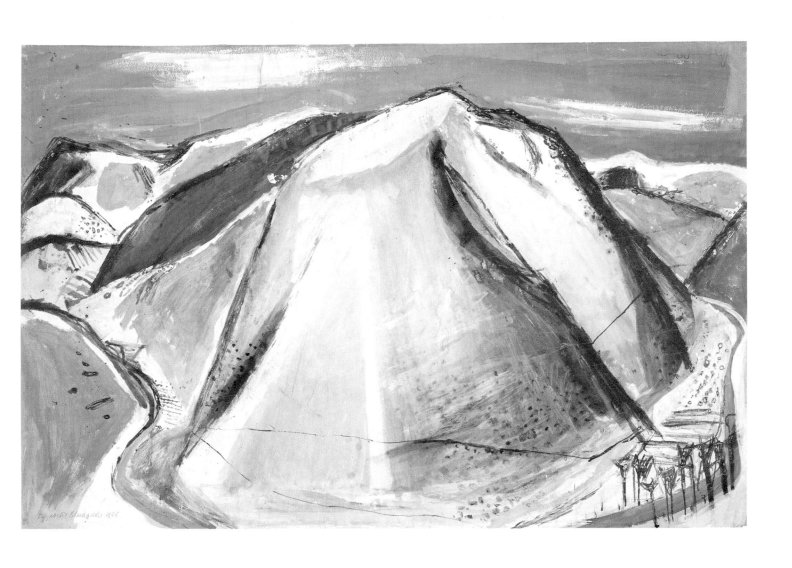

2 *Winter Landscape at Assisi*
1955 Gouache and ink 19¹/₂ x 29 in (50 x 74 cm)

houses or trees huddled among the bald shoulders of hills, are typical, though they also suggest that Gillies' favourite Lammermuirs have been translated to Tuscany.

Her palette was still very limited. A big watercolour of the Arno in Florence with a temporary wooden bridge still in place from the war is painted in low-key browns and ochres. The bridge itself is strongly drawn in black. But these works are impressive too, especially the drawings. In them it is as though she was reaching out to find the sombre strength she had sought in her painting by gripping the very bones of the landscape as she does in *Impruneta, south of Florence* (1956, Plate 3) for instance; and there is more than a note of continuity with the social-realist mood of her dark paintings in one detail on a drawing of the Tuscan village of Galluzzo. A dominant feature of the picture is a blank house-end. At the entrance to the village, it stands at the end of a strong curve in the road and together with a cluster of trees on the opposite side of the road it frames a group of houses in the village beyond. But prominent on this blank wall is a roughly painted political slogan. In place of an exclamation mark at the end of the inscription is the hammer and sickle of the Communist Party, then at the height of its popularity.

Elizabeth drew in pen, brush or conté crayon, and sometimes with a quill, exploiting its spluttering scratchiness to create dramatic tangles of line, often focusing the composition where a road, a dike, the line of a hill or the walls of a group of houses all converge in a kind of compositional knot that surprisingly leaves much of the rest of the picture almost empty, though never blank, for these empty spaces are drawn into the net of the composition. It is an effect that recalls Henderson Blyth. It is of course also familiar from Graham Sutherland and John Piper and others of this generation. But Henderson Blyth was not merely an imitator. She speaks warmly of the directness of his teaching and his insistence on the investigation of form and structure through drawing, clearly visible in his landscapes which are built up with strong lines, vigorous and expressive, but accurate too. His painting, like hers at this date, is also often sombre in mood.

Perhaps surprisingly given her later work, but certainly in keeping with this feeling for structure, a great deal of Elizabeth's drawing was of buildings. Italian architecture had been one of her subjects of study at university. That might help explain her initial interest, but not the authority of these drawings and the dramatic sense of structure, both architectural and graphic, that they reveal. A view of Siena looking across to the Campo is a brilliantly sustained essay in architectural form, her pen exploring the townscape house by house, analysing the details and appearing to ignore the wider picture as it powers its way through them, yet ending up with a drawing that captures that wonderful sense of integration that gives the townscape such humanity and grandeur (Plate 4). She still remembers, too, the dazzling impact of the striped marble architecture of the Duomo of Siena, and she drew it brilliantly (Plate 5). In spite of the sense of detail the drawing is free and the perspective leans away from the viewer, stressing the towering impact of the building.

She also drew the Duomo at Lucca and at Pisa with its great Baptistery. She

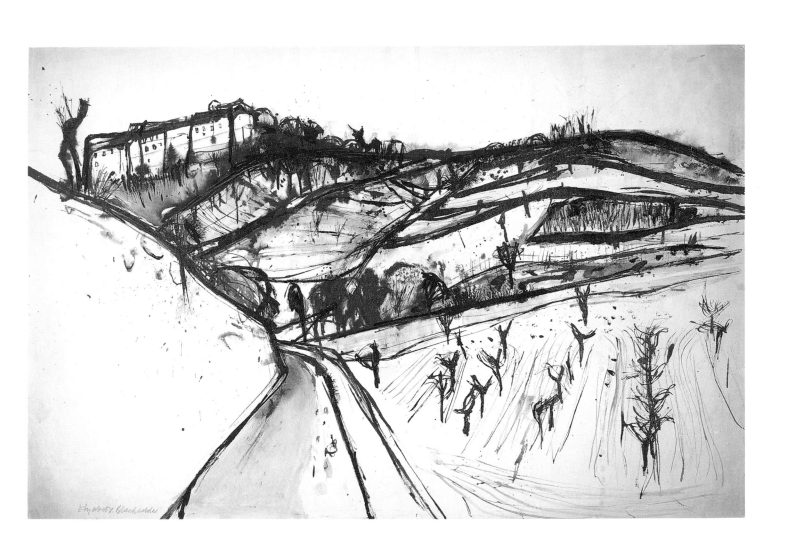

3 *Impruneta*
1956 Pen and ink 19¹/₂ x 29 in (50 x 74 cm)

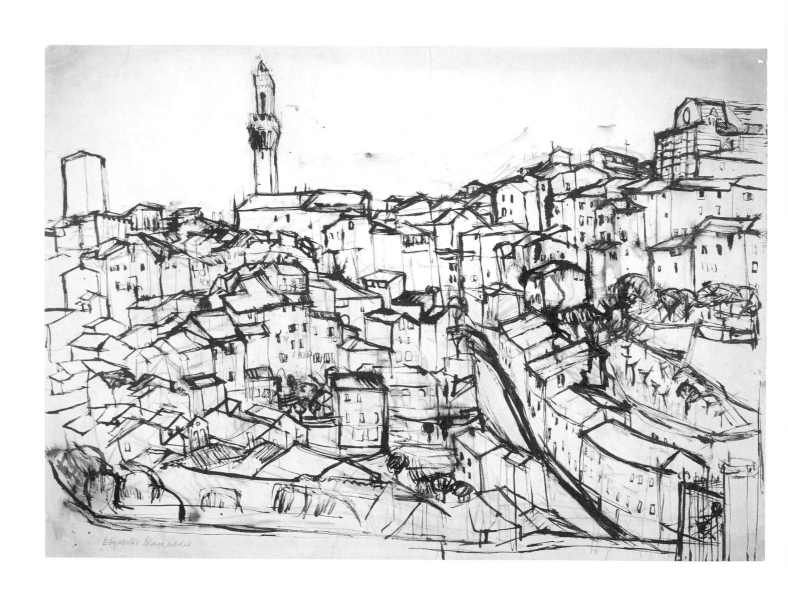

4 *Siena* 1956
Pen and ink 20 x 27 in (51 x 69 cm)

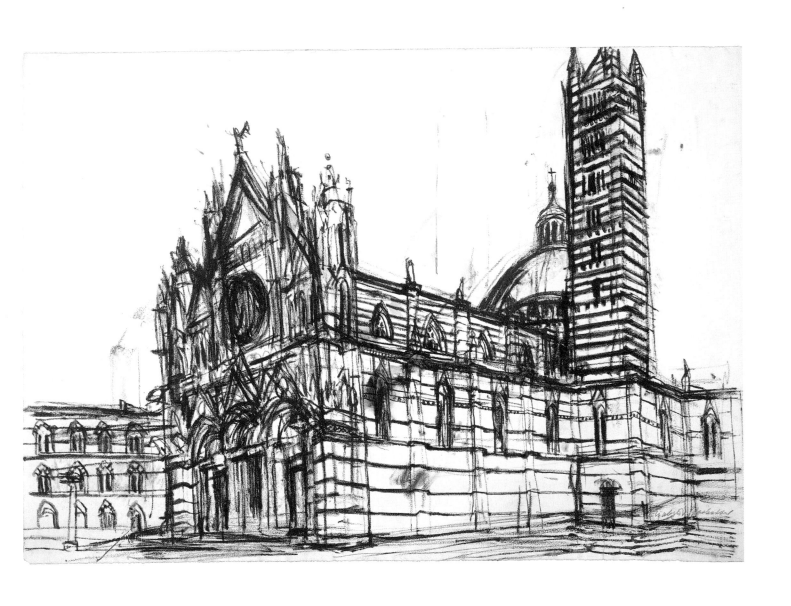

5 *View of the Duomo, Siena*
1955 Pastel 18¹/₂ x 26 in (47 x 66 cm)

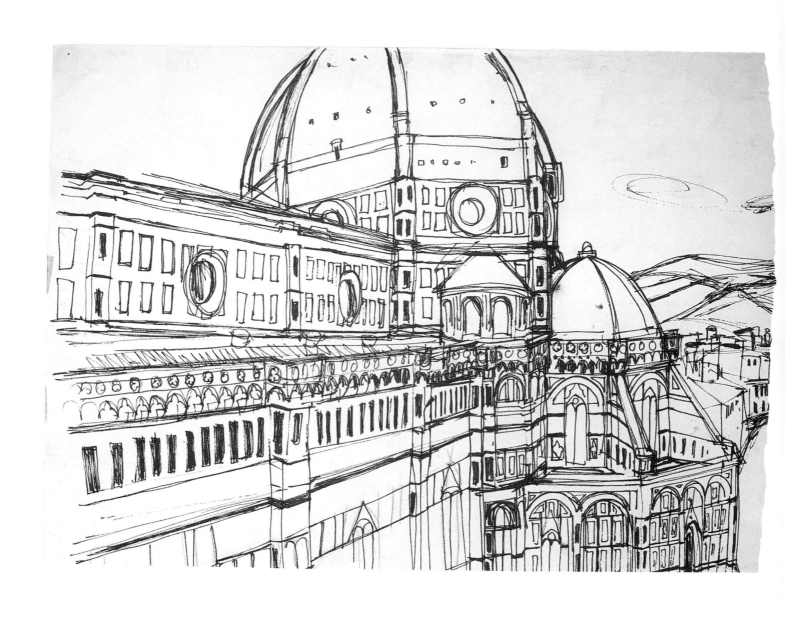

6 *The Duomo, Florence*
1955 Pen and ink 13 x 18 in (33 x 46 cm)

seems to have drawn the Pisa Duomo from a precarious perch on the open walkway of the campanile, the Leaning Tower. She drew the Duomo in Florence from a window in the Campanile there too, to create an astonishing investigation of the building, not a conventional architect's drawing at all, but like her later flower studies an inquiry into visual form where the intensity of feeling is entirely integrated with the description, so that neither one is subordinate to the other. In this particular drawing (Plate 6), one of many of the Duomo, the combination of this powerful sense of structure with what seems to be an almost arbitrary edge to the composition looks forward to the way she composes now, suggesting that what she has recorded may have its own integrity, but it is also part of a much greater continuum.

Elizabeth drew the Duomo in Florence many times. She seems to have been particularly fascinated with the east end where the apses huddle against the bulk of the dome. They buttress it, and it echoes their shape and so seems to grow out of them. After her return home she also made several paintings in oil and watercolour of this subject and perhaps if one was to look forward from these remarkable pictures to the way in which we know her art has developed since, it is this sense of structure, not in terms of architectural form, but of the placing of things and the way in which in these great buildings detail is never merely decorative but is orchestrated into the whole that is significant.

Elizabeth showed all this work in the College of Art on her return as was the custom. It must have been an impressive display, but these drawings still make such an impact now that an observer then might well have thought that her future was as an artist in black and white and it was certainly appropriate that one of her Italian drawings, *Tuscan Landscape*, was turned into her first important print, a lithograph that she made with Harley Brothers in St James's Square as the result of a commission from the Arts Council, still at the time represented in Scotland by the Scottish Committee.

. . . *Early Printmaking* . . .

Harley Brothers was a commercial lithographic printer with a first-class lithographer in Willie (also known as Jock) MacFarlane who later went to the Curwen Press. The firm had branched out from commercial printing into publishing artists' prints, working with a good many artists both from Scotland and from the South: Anne Redpath, Robin Philipson and Henderson Blyth, Michael Ayrton and John Piper, to name only a few. It was a rather haphazard organisation. John and Elizabeth frequently visited the printing works of Harley Brothers and they both made several prints there and Willie MacFarlane's instruction was really Elizabeth's introduction to printmaking. It was not part of the curriculum at the College for painting students and was only available to them in evening classes which she scarcely had time to attend. This print proved important, too, for it was seen by Robert Erskine of the St George's Gallery, at that time still an art gallery as well as a bookshop. When later the Gallery changed hands the print-publishing

side of the business was inherited by Editions Alecto.

Erskine commissioned a series of lithographs from Elizabeth of Hadrian's Wall which were made in 1961-2 and printed with Stanley Jones at the Curwen Press. Elizabeth had known the Roman Wall well since childhood. At that time a relation by marriage of her mother's, William Bulmer, had been curator of the Roman Museum at Corbridge and she had visited him there several times. The water-colours on which these prints are based, and several oils that derive from them too such as *Wall Town* (1961, Plate 7), are still very dark. In the watercolours she also uses a lot of body colour to create an opaque surface as she had done in Italy. But it was an earlier print done for Robert Erskine in 1960 called *Fifeshire Farm* that led in 1961 to a commission from the Museum of Modern Art, New York, for a print, *Dark Hill, Fife*, an impressive, but still bleak view of a landscape near Burntisland. And following this in 1962 the GPO commissioned a lithograph from her of Staithes in Yorkshire to serve as a poster in a campaign to promote the accurate addressing of letters. All of these prints follow directly from the style of work she had developed in Italy with strong, jagged black lines defining the composition, or gathering into a kind of investigative huddle around its main incidents.

From 1956 Elizabeth taught part-time at the College of Art, but these part-time appointments were only ever for two years and hers ended in 1958. She took a teacher training course at Moray House and in 1959 took a teaching post at St Thomas of Aquin's School in Edinburgh. But school-teaching was not much to her taste and in the same year David Talbot Rice came to her rescue and appointed her class librarian in the Fine Art Department at the University, a much more congenial environment that involved not only looking after books, but also the Department's slide collection. It was an opportunity to pick up again on the interests she had developed as a student. She stayed with the Fine Art Department until she was appointed to a full-time position at the College of Art in 1962, a post she held until she retired from teaching in 1986.

. . . *Paintings of the 1950s and 1960s* . . .

But her painting was moving on and in 1959 she held her first solo show at the 57 Gallery in Edinburgh in its tiny first floor premises situated on the north side of George Street. These had been the studio of Daphne Dyce-Sharp, a sculptor, who had left Scotland for Canada and had suggested that the unexpired lease on her studio could be used to turn it into a gallery. The suggestion was taken up and the gallery was founded in 1957 by a group of individuals including among others the sculptor Anne Henderson, Patrick Nuttgens, John Houston, David Michie and David McLure. Elizabeth could only show a dozen paintings and a portfolio of drawings in the 57 Gallery's one small exhibition room. These works mostly still derived from her travels in 1955-6, but in 1958 she and John had gone to Spain for the first time and though she did not show them on this occasion her Spanish pictures suggest the beginning of a new direction in her work. One relatively large

7 Wall Town
1961 Oil on canvas 34 x 44 in (85 x 111cm)

Spanish painting, for instance, shows a group of matadors, the colours of their costumes glimmering in the darkness. Another shifts decisively towards the light with the figure, again of a matador, framed by a large area of white that is built up of heavily bodied pigment that is almost like plaster relief. But she was looking two ways as in spite of this the matador's brilliant costume is not much more than a glimmer of colour against black.

This picture is dated 1958 and seems to be a bit of a one off, an experiment, perhaps inspired by de Stael's use of heavy paint that is sometimes almost like relief (twenty-five works by de Stael had been shown at the SSA in 1956). This was followed in 1958 by an exhibition of works by Dubuffet and others from the collection of London photographer, Anthony Denny, also shown at the SSA under the heading of *Tachisme*. Elizabeth was directly involved in this as John selected it along with James Cumming. Then at the Festival that year the Moltzau Collection of School of Paris paintings was shown at the RSA. Contemporary French painting still represented the avant-garde for most people, but also in 1958 in London the Whitechapel started a series of exhibitions of contemporary American painting with Jackson Pollock. This was followed later by Rothko, Rauschenberg, Johns and others. It was a series of exhibitions that helped eventually to turn the attention of British painters away from Europe towards America. John and Elizabeth saw the Philip Guston exhibition in this series.

Elizabeth's own work became more experimental in the late 1950s and early 1960s. After the *Matador* in 1959 she made a small print of musical instruments, for instance. A grand piano dominates the foreground. A group of wind instruments hover above it. There are a couple of musicians dimly discernible behind, but otherwise the instruments and the composition that they make seem autonomous, not dependent at all on conventional structures of space or narrative. It is a crowded composition and not a typical work by any means, but one she recognises now as much freer than anything she had done before.

Rather like the *Matador* too, a series of still-lifes that she painted over the next few years such as *Still-Life with Turkish Coffee Mill* (1964, Plate 8), though not so heavily painted, end up with a single, unifying tone laid over quite heavily worked paint. This frames objects distributed over a surface, usually only summarily identified as a table. The Turkish coffee grinder, a sky-blue Venetian glass goblet, and various other objects all appear several times, drifting through the picture space, not on the surface exactly, more suspended in this field of paint. Other visual incidents are sometimes scarcely defined things at all, a palimpsest beneath showing through the final paint surface, fragments of a secret world beyond as the layers of earlier painting are glimpsed, half-recognised, like memories beneath the level of the conscious mind.

This series of still-lifes is perhaps the first really major group of paintings that Elizabeth made. Some were shown at her second solo show, held at Aitken Dott's in 1961. Still-life was to become central to her work from that time forward and in these pictures, though they are very differently painted from the way she has painted since, we already see some of the characteristics that make it distinctive.

8 *Still-Life with Turkish Coffee Mill*
1964 Oil on canvas 24 x 30 in (61 x 76 cm)

For instance she treats pictorial space as an imaginative dimension, not bound by any other discipline than the surface and the edge. Although in these pictures this is achieved by layering the paint, within the imaginative space that she creates she gathers objects by a process of free association that is intuitive, private even; but because of the way the picture is structured and the manifest feeling with which the objects are described, it is all nevertheless perfectly accessible to the spectator.

One of these still-lifes won Elizabeth the Guthrie Award when it was exhibited at the RSA in 1962. The Guthrie Award is the Academy's top award for a young painter and the list of those who have won it reads like a roll call of the best painters down the generations. It is a reflection of its importance that the award was followed in 1963 by her election to the Royal Scottish Academy as an Associate (ARSA). The picture that won the Guthrie Award is called *White Still-Life: Easter*. As the title indicates this is a white picture, but though it is certainly no longer gloomy, the colour is still cool. The picture is freely painted. A table covered with a white cloth is tipped towards the viewer. There is a narrow band of horizon above, just enough to establish the idea of a larger space. But a curtain or a patterned cloth down the left-hand side is integrated with the surface of the table by a series of horizontal bars that might be patterns of light from a window. A group of objects is ranged in a line in profile across the table, a bottle, a goblet and a painted Easter Egg which gives the picture its title. Some of the objects are outlined by an opening in one layer of paint that defines their shape painted in another layer beneath. Others are less clearly defined, drifting away into the texture of the paint, or seen from above so that they are flat and merge with the broader patterns of the composition.

But though this is plainly a mature painting and still-life has been her most characteristic mode of expression since that time, it had not featured largely in Elizabeth's work hitherto. Although it was part of the curriculum of the College, she thinks she did not realise before this date the potential it really had: that it did not need to be literal, but offered scope for invention and extemporisation. Nevertheless the still-lifes she had painted before this do include some good painting: fish on a plate for instance, a subtle study in greys, or spiky flowers in a black jug. There is also a damaged fragment of a large painting from 1956 of a meal on a table painted in cool greys with dark figures behind it. The table is tipped towards us in a way that was to become typical later and the objects on it are much more strongly painted than the figures behind them. There is perhaps a memory of Morandi in the handling and of other contemporary Italian painters in the composition.

It was, however, only around 1960 that still-life became one of her principal interests as it has remained. She reckons that Gillies' example was important to her, and that of Penelope Beaton too whose work she knew well, for as with Henderson Blyth she had remained on close and friendly terms with her former teacher. Gillies treated still-life very much as an experimental vehicle, exploring the dynamics of composition in a way that was rather different from his approach to landscape. Elizabeth has used it in a rather similar way to this ever since this first series of major still-lifes that she painted between about 1960 and 1963.

But also, when they were first married, John and Elizabeth lived at 7 London Street in the flat above Anne Redpath. Naturally they became very friendly and it was a period when Redpath was painting some of her most inventive pictures, including some very striking still-lifes which are richly painted and loosely composed: objects suspended in a dynamic field of paint, more than lodged on an illusionary surface. They are also much less self-conscious than Gillies' still-lifes which sometimes seem to creak with effort.

The Houstons were neighbours of Anne Redpath for seven and a half years, moving from London Street to Queen's Crescent in 1963 only two years before she died. It was an important friendship though there is not much obvious influence of the older artist's work on Elizabeth's over these years. Looking back on it she herself sees what she was doing then in the context of a much longer tradition, and she recalls too other more immediate influences, contemporary Spanish painters for instance; but if Gillies started to seem relevant to Elizabeth then, perhaps it was because of the way that Redpath was helping her to see the possibilities of still-life and conduct her own experiments with it. It is also true that for the first time one can perhaps see echoes of Bonnard in these compositions. Elizabeth remembers Gillies' enthusiasm for Bonnard and she herself has always held the French master in the highest regard, but it is only when she starts exploring still-life with tipped table tops and objects so strongly seen that they somehow create their own space that Bonnard's example seems directly relevant to her own work. Here again perhaps Redpath was the intermediary. And in Redpath's still-life painting we get a strong sense of intimacy, that these still-life objects are part of her world. It is a kind of extension of personality, something that subsequently Elizabeth has come to share with Bonnard more even than Redpath did. Certainly, though this kind of associative feeling informs Gillies' approach to his favourite landscapes, it is only rarely true of his still-life painting where often one feels as though the objects have just come cold from the classroom cupboard and have inspired little curiosity in the artist.

In 1962 John and Elizabeth went back to Greece, travelling to places they had been unable to visit the first time and extending their journey up to Istanbul for several days as well. Paintings of the Blue Mosque and of Mykonos are memories of this trip. In some of her paintings, in *The White Tower, Myknonos* for instance, there are still echoes of her earlier more sombre Greek paintings: white buildings poised above bare hillsides. But the watercolours have a new luminosity. In *Façade Mistra* (1963, Plate 9) a white church floats in the sunshine. It is a wonderful sunny vision that follows on from her earlier architectural drawings, but light dissolves their severity to make Greece, suffused with sunshine, look almost like Venice as Turner painted it.

On this occasion they flew to Greece, but in 1960 their opportunities for travel changed dramatically. After a successful exhibition John bought their first car, a Hillman Minx. This gave them new freedom of movement and they took advantage of it to travel first to Brittany in 1961 and to France regularly in the years that followed, going on to Spain and Portugal in 1965 and again in 1966. So throughout

9 *Façade, Mistra*
1963 Watercolour 27 x 31 1/2 in (69 x 80 cm)

the 1960s there are regular landscapes of places in France, Spain and Portugal, and also of parts of Scotland that they could not reach easily before, of Skye, Argyll and the north east for instance. Mostly these pictures are in watercolour. There is a remarkable watercolour of a lily pond painted in 1965, for instance, a subject she was to return to twenty-five years later. This pond was at Ardkinglas, a house in Argyll designed by Sir Robert Lorimer and the home of John and Elizabeth Noble, collectors whom they visited frequently in these years. John Noble had recently taken over the Dovecote Studios from the Marquis of Bute and Elizabeth's first tapestry was made at Dovecote by Archie Brennan for Ardkinglas. It was taken from an early, dark still-life of tulips in a jug.

There are occasional landscape oils too. She paints a church in Brittany in cool greys and whites (Plate 10), and cows in an orchard in Normandy camouflaged among the trees. The latter picture is painted with heavy impasto, not built up as the result of layers of working, but as a response to the subject and the demands of the painting. Since then thick paint has never been a feature of her work, but even so this does point away from the heavy, layered painting of her earlier work towards a more direct way of painting where it is possible to see on its surface the whole process of a picture's making. But another equally important shift in her art was taking place at this time. Already in the Matador pictures, though its brilliance is checked, the vivid colours of the costume, of something made, had attracted her. Now she sought out these things. In Portugal the colours that the houses were painted and the patterns they made attracted her; a dark house is framed by a band of bright blue decoration against the sky. Similarly the jazzy colours at a fairground, or some blue, white and violet, zig-zag decoration seen in Portugal are transferred into paintings unmodified as in *Portuguese Still Life* (1966). Discovering Matisse was part of this change towards bright colour too. In the summer of 1964 as they travelled through France, almost on a whim John and Elizabeth drove down to Nice to visit her grandfather's grave, for he had died on one of his regular visits to the Riviera. This trip gave them an opportunity to visit the Matisse Chapel at Vence as well as the Picasso and Léger museums nearby.

For the first time, they were travelling in the summer. It was probably this as much as anything, John reckons, that lightened Elizabeth's palette and so the mood in her work. They were seeing the Mediterranean light in all its brilliance, the light that had played such an important part in the evolution of modern painting, from Cézanne through Matisse and Bonnard, and they were very much aware that this was historic territory. Elizabeth began a series of paintings and oil pastels during this first visit to the South of France that she continued over the next three years. They are of the beach at L'Esterel near Bonnard's home where red rocks drop into a bright blue sea and bathers add animation (Plate 11). These pictures clearly reveal the change that was taking place in her work. They reflect her response, not just to the stimulus of light, but at a deeper level to the art of those whom it had inspired before her. Dark reds and dark blues still dominate these pictures, but the effect is intense nevertheless and these deeper tones are no longer sombre but suggest heat, and the strength of the light as they do in some of Bonnard's

10 *Church in Brittany*
1963 Oil on canvas 30 x 40 in (76 x 102 cm)

11 *Bathers, L'Esterel*
1966 Oil on canvas, 39¹/₂ x 49 in (100 x 125 cm)

paintings of the view into his garden under the midday sun. And are these bathers with their solid shapes dissolving in the light even a memory of Cézanne? Certainly in a picture like *Bather* exhibited at the Mercury Gallery in 1967, the single figure seated beneath a wide horizon is a homage to Matisse's bathers, if not to those of Cézanne before him.

In a *Self-Portrait* painted a few years later in 1972, which like the Esterel pictures is also partly in oil pastel, Elizabeth seems to reflect on this new mood and the heritage behind it. The scene appears to be a Mediterranean balcony with a brilliant red, green and yellow rug spread out beneath what seems to be an intense blue sky. There are clothes on a chair, striped and brightly coloured. An equally brightly coloured towel or rug seems to be flying against the blue sky as if to say that the rules that prevail here are the rules of an alternative brilliant, joyful, painted world. Seen in profile the artist is depicted entering the picture from the right wearing a blue check dressing-gown. But in contrast to the brilliance of the rest of the picture, the ground she is standing on is grey. Even her face and hands are grey. It is as though she sees herself at a moment of transition as she enters the luminous world of Matisse.

In the beach landscapes that led up to this picture, some of which were done on the spot, her execution is much more rapid and informal than it had been before. In the oil pastels she clearly is working directly, putting things down as she had seen them as she had always done working out of doors, but now also working the same way from memory with a confidence that allows the composition to grow out of the marks she makes. Perhaps she had anticipated this in her extraordinary architectural drawings of almost ten years before, but in the middle 1960s this emphatic handling becomes a distinctive feature of her work as execution and composition merge and the marks the brush makes assume their own identity. *Summer* from 1963 (Plate 12) is a very beautiful picture that already points the way she was to go. Indeed there is a watercolour still-life that she painted four years later with the same coffee pot in it, but more importantly too with the same luminosity, for though *Summer* belongs with the other still-lifes of the early 1960s, it has a freedom and light that are new.

Although Elizabeth did not visit Portugal till 1966, a piece of Portuguese embroidery features prominently in this picture. This embroidery in turquoise blue and white, a tall, dark blue enamel coffee pot and coffee grinder, also tall and narrow with delicately curved handle, a green painted Easter egg and one or two other familiar objects drift in a luminous space. All these objects are small, just incidents in a continuum. The picture is suffused with a beautiful, soft, dappled light. At the edges this light is enough to suggest that this is a table. There is a halo of light round the coffee grinder. Little pools of light across the bottom are on the same scale as the objects. The picture has a wonderful unity even though it seems so loosely organised. The mood is relaxed and sunny, a Mediterranean breakfast perhaps. The light tone is no longer just a veil over hidden darkness. It is light celebrated for its own sake as it was in the watercolour of a Byzantine church that she painted the year before.

12 *Summer*
1963 Oil on canvas 40 x 50 in (102 x 127 cm)

There is another very beautiful still-life with a similar character from 1965, *Still-Life with Grey Table* (Plate 13), that Elizabeth remembers as particularly satisfying at the time: that in it she had reached something that she was searching for, something she speaks of now as a kind of spaciousness. This is quite a large painting, looking down onto a collection of objects on a table top. There is space around it, enough between the edge of the table and the frame to allow it to be seen as a table, but not much more. The objects against the table are very cursively drawn. It is this cursiveness that gives a feeling of spaciousness, and indeed the brush marks, as much as they define the objects, supplant them, becoming objects, or rather events in themselves. Nor are they confined to the arrangement on the table top. There is a series of brushmarks between the top edge of the table and the top of the frame that seem just to be there as a rhythmic pattern that creates a space by its energy, much as clouds give drama to the sky. Curiously this effect can be seen most clearly in a tapestry that was commissioned by John and Elizabeth Noble for the Scottish National Gallery of Modern Art. Made at the Dovecot Studios, it was completed in 1967. Perhaps thinking of the process of translation into weaving made Elizabeth especially conscious of the language of mark-making out of which a picture is built, but this tapestry is almost a vocabulary, a thesaurus of marks.

This tapestry is almost as abstract a work as she has ever made, but even here the thought process, if still concrete, focused down into the tangible moment of exchange between her tool, her medium, her hand and the surface; and even this degree of abstraction is rare. Usually it is visibly informed by associations and so by information of one kind or another: a place, an object, later a plant or a flower, often a memory enshrined in a drawing. A lovely watercolour of Pistoia for instance probably dates from the mid-1960s, yet its origins are in a visit she made in 1955-6 during her travelling year, and looking at it one can see the refining process of memory. The inessentials have faded and all that is left in high focus is the thing that mattered most, the beautiful details of the oculus and entablature that crown the façade of the church. The surroundings are as much the drifting fields of memory as they are constructed urban space.

Elizabeth talks about the importance of memory, of how it refines things, clears away all the incidental details that obscure what is essential to the character of a scene. Ever since her first trip to Yugoslavia and Greece she had brought home her experiences of travel to inform her painting, her memories in the form of drawings to be transmuted in this way, often years later. A beautiful watercolour of Aegina for instance that she exhibited in 1967 is actually dated 1966, though it was more than ten years since she had visited the place. She does this still, and more and more, like her grandfather and Anne Redpath too, these portable memories are in the form of objects, tangible souvenirs; and that word so debased in English still means originally just 'memories'.

But this attitude to travel is very different from Gillies, or before him the elder McTaggart, whose best painting is of the landscapes most familiar to them. McTaggart never painted outside Scotland. With Gillies, though he painted in Italy and France early in his career, later even the West Highlands seem exotic. But

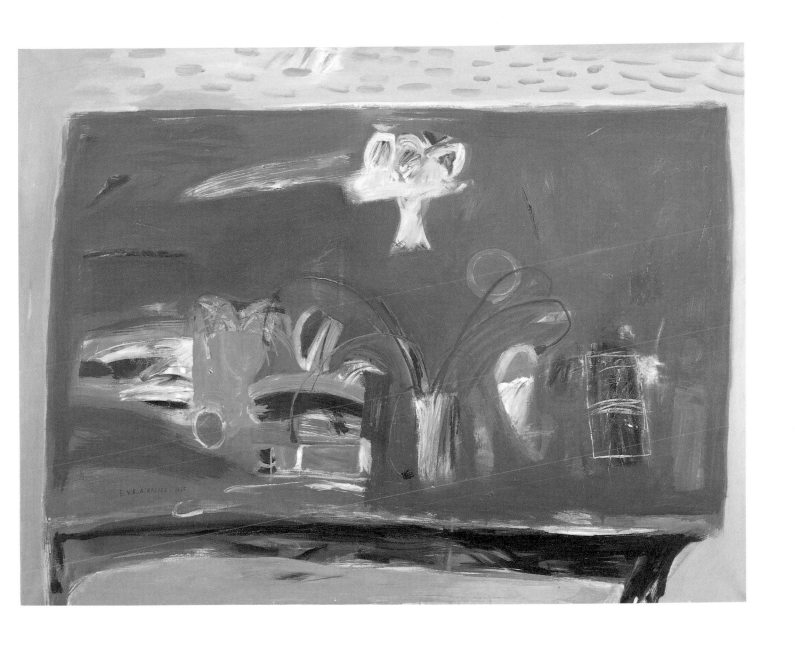

13 *Still-Life with Grey Table*
1965 Oil on canvas, 40 x 50 in (102 x 127 cm)

this love of travel was something that Elizabeth did share with Anne Redpath. For Redpath, too, travel was vital inspiration, not only for the places she visited, but the things she brought back from them that became part of the vocabulary of her still-life painting. Indeed a Mexican painted angel that Anne Redpath bought as a present for Elizabeth in London appears in one of Elizabeth's still-lifes from this period and this process of making her still-lifes out of objects rich with associations has been central to her painting since that time. Several paintings of a Spanish rug for instance just take the object itself and make it into a painting. A few objects are scattered against it and the shape of the rug fills almost the entire picture field, serving much as the table top does so often in her work as a kind of short-hand for picture space. One brilliant example of this series is *Red Spanish Rug* from 1966 where a vase of tulips is set against the red ground of the rug, and a similar effect is seen in *Flowers on a Black Table* (1968, Plate 14).

. . . *The Mercury Gallery* . . .

In 1965 Elizabeth exhibited for the first time with the Mercury Gallery in London, and the following year for the second time with Aitken Dott in Edinburgh. Since that date she has shown every two or three years with the Mercury. She exhibited again with Aitken Dott in 1972 and 1974 (by then it had become the Scottish Gallery), and in 1982 and again in 1985 she showed with the Mercury in Edinburgh when it had a branch in the city, but otherwise, though she sent work regularly to the RSA and exhibited in various group exhibitions in Edinburgh, she did not have a solo exhibition in her home town again, apart from the retrospective at the Fruitmarket Gallery in 1981, until 1994 when she began to exhibit once again with the Scottish Gallery.

The connection with the Mercury began in 1963 while John and Elizabeth were still living in London Street. Eric Raffles came to Edinburgh on a talent-spotting expedition (he made a great impression by flying his own plane), and the Tib Lane Gallery in Manchester had given him Elizabeth's name. Since then the Mercury has been central in establishing her reputation with a wide public, mostly in this country, though occasionally she has also exhibited abroad, for the first time in Florence in 1970, then in New York and Toronto in 1982 and in New York again in 1983 and 1986. Of course as her exhibiting career flourished, so too her self-confidence grew. In the early years at the Mercury, for instance, it did her sense of her own standing no harm to be seen in mixed exhibitions along with Picasso, Dufy, Matisse and other modern masters. Indeed in a catalogue from 1967 one of her early watercolours of Siena makes a John Piper watercolour of St George in the East reproduced alongside it look rather stilted.

The dialogue visible in her painting in these years and especially in the still-lifes is part of this visible increase in confidence. On the one hand as she matured as an artist and gathered her self-confidence it seems she was able to come to terms with the tradition in which she had been trained. She became then and she still is the heir

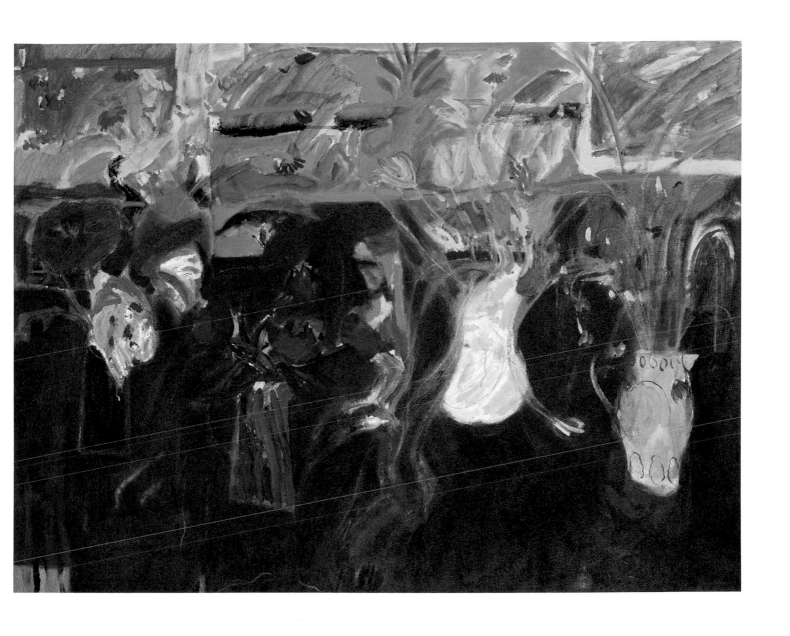

14 *Flowers on a Black Table*
1968 Oil on canvas 34 x 44 in (86 x 112 cm)

of Gillies and Redpath. But on the other hand, cross-fertilisation is a vital part of artistic inspiration and, though she has never been as artistically promiscuous as Gillies in her willingness to experiment, Elizabeth has always been open to new ideas, willing to follow them into a dead end if that is where they led, or to watch her art grow under their impact if the ideas proved fertile.

And this was the 1960s. For whatever reason it was an era of optimism, expressed through colourful ideas and attitudes. A painting of a butterfly that Elizabeth exhibited at the RA in 1968 is as joyful an expression of this as you could wish. The picture is a metre across and the butterfly with spread wings stretches over two thirds of that. The background is loosely painted green, the colour of the insect's environment, but nothing else is specified except two flower heads, a drift of this-tle down, and the stem of the plant that the butterfly is sitting on. This is a painting entirely in the spirit of the 1960s. Its simplicity echoes the brilliant colour field painting of those years, of Morris Louis, or the spacious figurative painting of Milton Avery, but it is independent too in the way she uses the language of con-temporary abstract painting to maintain a dialogue with the natural world and find poetry there. Perhaps, though it is so much simpler, the closer comparison to this kind of pictorial poetry is with John Eardley's wonderful paintings done ten years earlier of summer meadows on the cliff tops at Catterline.

At another level this simple badge-like image of a butterfly suggests Pop Art. Much of the work produced under that banner may have been superficial and ephemeral, but there were things about it too that aroused Elizabeth's curiosity. The general informality of Pop culture is clearly reflected in her contemporary painting. Hockney's casual habits with composition, for instance, or the half-completed, yet sufficient statements with a brush that he made (a habit that he shared with Kitaj), all find a clear echo in Elizabeth's work in these years. But looking further afield to America, one of the most important ideas at the heart of the Pop movement launched in England by Paolozzi in his ICA lecture back in 1951, but expressed for the 1960s by artists such as Warhol and Oldenburg, was the attitude to the object.

Once, to be worthy of art, objects had to have some kind of aura; now they could be taken as they came. Even the most humble things could be recognised as vehi-cles of artistic invention invested with their own brilliance. John tells a story of how they astonished a shop assistant in Woolworth's in Perth by buying every imaginable variation of striped rock. Its brilliant colours and patterns were more easily digested artistically than they would have been if it had been intended to eat it all, something perhaps the shop assistant could not grasp! Similar, brilliant colours caught her eye in a fairground at Nazaré (in Portugal) where she saw a group of vivid naïve paintings decorating a booth and adopted them directly into a composition of her own. The brightly painted, wooden Easter egg that had given its name to her Guthrie Award picture is typical of the objects of this kind that appear frequently in her still-lifes from the early 1960s onwards, but increasingly she collected games and painted toys, brightly coloured boxes, embroideries and handmade things, but modern objects too. A handbag made of bright plastic beads appears in several paintings such as *Still-Life with Japanese Flowers* (1969, Plate 15).

15 *Still-Life with Japanese Flowers*
1969 Oil on canvas, 44 x 56 in (112 x 142 cm)

Often such an object is the only really sharply focused thing against a loosely constructed ground. In one example an egg painted red and emerald green sits casually in a roughly brushed ground that suggests architecture, but only just. In another an equally informal red and orange ground has objects loosely scattered against it. A piece of embroidery and a cloth-covered box make little jewel-like incidents of high focus in a free-flowing coloured field. It is a kind of painting that is plainly extemporised. She never really did set up a still-life and faithfully work from it as a formal arrangement of objects, but increasingly she brings them together in the painting as the mood takes her or the composition suggests. More and more the picture is a kind of toy box, or more accurately a remembered toy box. Objects of all kinds are gathered together, rubber balls, games and toys, ribbons, all kinds of brightly painted objects collected on their travels. And *Objects in a Cupboard* (1969) is just that, a vertical painting with objects ranged on shelves – an Easter egg, the Turkish coffee mill, pieces of china and glass, plates and such like. But though the shelves are indicated, the space is suggested, not constructed. In softly brushed white, grey and ochre, some of the objects are no more than ghosts, shadows in the mist of memory.

Even so, looking at these pictures now, between them John and Elizabeth can still identify what these objects are and where they came from. They have not lost their identity as they have been fused into the new larger identity of the painting. Nor are they simply picked up and put down again in the middle of a painting, for they are touched by memory and imagination. The picture is more and more a mindspace, not a literal space at all and so objects can form and dissolve in it as they do in the projections of our consciousness. It is perhaps this kind of imaginative spaciousness that she feels she realised in *Still-Life with Grey Table* in 1965 (Plate 13).

This imaginary space was already a feature of her first major still-lifes, but around 1968 she found a new inspiration for it in an exhibition of Indian miniatures at the 57 Gallery, the result of a partnership between John Kasmin and Howard Hodgkin who had been to India on Kasmin's behalf to collect them. John and Elizabeth were very taken by these and bought two very beautiful paintings which they still have. Two pictures from this date, *Prayer Rug* and *Flowers and a Red Table* (Plate 16), are good examples of her interest in the way such pictures work. In the former a mug and goblet, seen in profile, float alongside the rug that gives the picture its title. In the latter the ground is a rich, Indian red, not the pigment of that name, but the brilliant colour associated in India with the Jains. Ranged along the bottom of the picture and outlined against this brilliant red are a blue striped jug with red and blue flowers in it, an unidentified black object and what seems to be a piece of printed cloth. As there is so often in Indian miniatures, there is a frame painted into the picture. The objects appear to sit on it and so it becomes part of the picture space. Almost twenty years later she returned to this device in a series of exquisite small paintings where she deliberately set out to use a collection of old mounts, painting the mount and the picture together.

You can see how the combination of beautifully observed and delicately painted

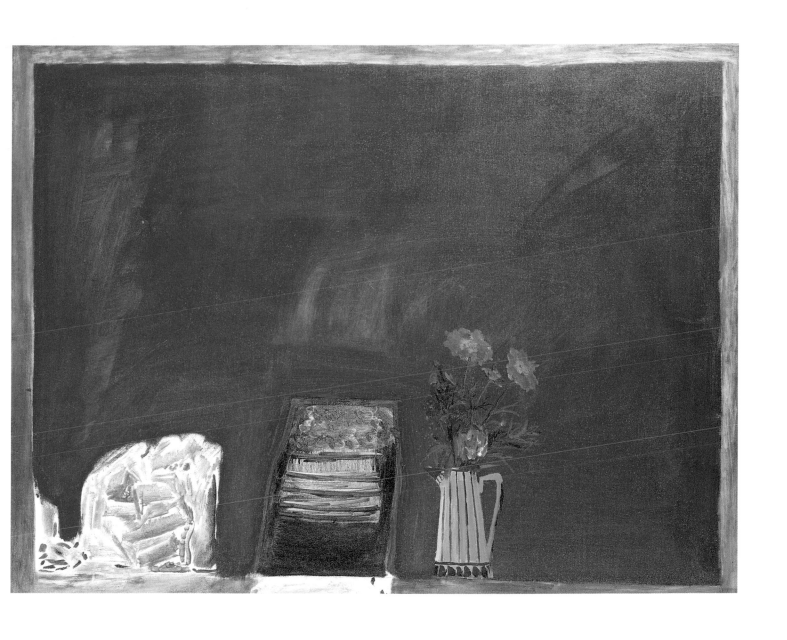

16 *Flowers and a Red Table*
1969, Oil on canvas, 34 x 44 in (86 x 112 cm)

detail and strongly constructed but minimal, flat picture space in Indian painting appealed to Elizabeth at the time. She was only half-joking when, looking at these pictures, she remarked that her interest in this kind of thing runs right through her work, from her study of Byzantine art as a student down to the interest in Japan and Japanese painting that was part of her inspiration long before she and John first went there in 1985. Thinking back to some of the still-life detail in Byzantine mosaics, the way it is organised and the richness of effect it achieves, then it is clear that she is not being fanciful in seeing a connection. Indeed she made the same point in conversation with William Packer while discussing the increasing freedom of the construction of her still-life painting:

> The way of setting out the objects was already developing in the oil paintings and still-life that I was doing in the mid-seventies. The table-top or whatever it was I set them out on was shown as tipping forward closer and closer to the picture surface. It was really just a question of losing the table altogether. Some people have seen this as coming from the example of Anne Redpath, but I see it more as a common tradition that goes back even to Byzantine painting and mosaics. It certainly gives wonderful freedom from the conventions of later Western art. (*Elizabeth Blackadder*, Aberystwyth 1989, p22)

. . . *Paintings of the 1970s* . . .

In 1969 John was invited by Mrs Johnson of Johnson's Wax who had some of his pictures in her collection to visit America for the first time. He and Elizabeth stayed in Racine in a new and luxurious apartment on the shore of Lake Michigan. Frank Lloyd Wright had built the company office in Racine and their apartment was close to a school built by his associate, Wes Peters. Racine is near Chicago and so they spent time in the Art Institute there. They also stayed in New York and travelled to Washington and Philadelphia. It was an important trip for both of them. The apparent abstraction and austerity of much of Elizabeth's painting in the early 1970s perhaps more generally reflects the mood of the time than any particular American influence, but she certainly looked closely at American painting while she was there. Looking at a *Still-Life with Hearts*, for instance, painted several years later in 1977, she recalled how Jim Dine had painted hearts in a similar way, so she was always very much aware of her American contemporaries.

Though he painted some very fine pictures in the United States, John remembers how in the atmosphere of the early 1970s, dominated by conceptual art, he found it increasingly difficult to paint in the way that he had always done, that is with a clear reference to the concrete world of experience. Perhaps the increasing austerity of Elizabeth's painting was in part a reaction to the same mood. But at the same time she approached this shift in the *zeitgeist* in a positive spirit. There are a

good many pictures that she painted in the early 1970s that include what appear to be the purely abstract geometric patterns that painters such as Frank Stella or Kenneth Noland were using at that time, but in fact they are paintings of patterned objects; an embroidered garment laid flat, for instance, in *Dark Still-Life* (1974) much like the *Butterfly* (1968), or shells and coral in *Still Life with Shells* (1971), a big, softly painted still-life that was exhibited in the Edinburgh School exhibition in 1971, a fan and striped jug in *Still-Life with Mexican Fan* (1969), or a fan again and polished agates in *Still-Life with Mexican Fan* (1970). In *White Still-Life with Ribbons* (1970, Plate 17) the ribbons accompanied by a few other objects wander across a picture space that is no more than the white priming of bare canvas. A picture in this group that she remembers with special fondness is *Grey Table* from 1970-71. As with the earlier *Still-Life with Grey Table* of 1965, it is once again a kind of spaciousness that she sees in it. A black and white marble box and another smaller box make severe geometric shapes. Alongside them two other sharply drawn rectangular shapes turn out to be plastic salt and pepper pots. A multi-coloured ribbon cuts in from the top left echoing the colours of a piece of patterned cloth laid out top right. A thin line of red at the top suggests there may be space beyond. The ground is minimal, barely articulated, no more than a layer of thin scumbled wash, using turpentine to turn oil paint into something as loose and transparent as water-colour.

But if American painting and Pop Art find some reflection in her work of the time, there were other things that she saw in America that had a more enduring influence on her and that my be reflected in pictures like this. It was in Chicago and also at the Freer Collection in Washington that she saw Japanese screen painting at its very best for the first time. She also saw Japanese art in the homes of people in Wisconsin, for there were a good many with the Johnson Company who came and went regularly to Japan. It was some time before she absorbed the lessons of this marvellous art, but following on from her interest in Indian painting even at this stage it reinforced her confidence in what was surely already a manifest ambition in her work, to create a kind of poetry that was autonomous, yet that celebrated the cherished beauty of the perceived world. It was quite a brave ambition at this time, but then as she has done since, she stuck to it unflinchingly and with unfailing imagination.

It was an ambition that, looked at away from the rather hectic atmosphere of the late 1960s and 1970s, and in the longer perspective of twentieth-century painting, was not so eccentric after all. In New York she found in Mondrian's work, for instance, visible there as nowhere else, not just confirmation of this approach in general, but also inspiration for another developing branch of her interest which emphatically took her back to the natural world, her flower painting. Elizabeth remembers first seeing Mondrian's remarkable flower paintings there and how important they were for her. But thinking of Mondrian more broadly this interest also suggests a commentary on her own wider ambition, for Mondrian's flower pictures are not a diversion from his main interest as a painter. They confirm it because they reflect his deep engagement with the world of experience, even

17 *White Still-Life with Ribbons*
1970 Oil on canvas, 50 x 54 in (127 x 137 cm)

though the results seem so abstract. Because it is linked to the real world in a way which is imaginative, sympathetic and particular, not general, her own painting never became abstract as his, but its structures are often almost as minimal, sometimes no more than two tones divided by a horizon line, or a single tone with a barely marked border.

The *White Still-Life with Ribbons* mentioned above, for example, is no more than the primed canvas with objects distributed across it. One ribbon snakes in from the left and out at the top. Another crosses the canvas and ends midway. A brightly coloured rectangle of embroidered cloth, another of patterned brown cloth and a few other objects make abstract shapes. The bare white ground works as it does in Mondrian's grid paintings and the objects define the space by their relationship to each other and to the edge of the picture in much the same way as the lines of his grid. In a good many other pictures from these years, too, striped ribbons in primary colours cut across the picture space and objects define their own relationships to each other and to the edge of the canvas in this way. In *The Necklace* (1974), for instance, the composition is even more spare. A scumbled white ground is divided by three roughly horizontal lines. The spaces they define are only distinguished by the direction of the paint. The necklace of the title is made of beads and is laid out flat. A small black and white box makes a moment of intense detail near the centre of the picture. Another patterned object near a horizon that might be the vestigial edge of a table is touched with red. Otherwise the picture is almost just black and white. It seems to be minimal in the way that Mondrian is: minimal without being truly abstract, without losing that last imaginative link to the perceived world, rather seeking to find a harmonious equivalent to it than to turn away from it completely. It is painting that works like music.

A closer contemporary than Mondrian was William Scott whose work comes to mind here. John and Elizabeth had first met him in the early 1970s when he came to Edinburgh as a visitor to the College. They met him again in New York in 1986 on the occasion of Elizabeth's second exhibition there and his abstract still-lifes offer a close analogy with these developments in her own art. Certainly pictures like *The Necklace* and *White Still-Life with Ribbons* established the vocabulary of her still-lifes for the rest of the decade and much of it was equally austere. However in the late 1970s there was a new departure in her art that seemed to point in a very different direction.

. . . *Flowers, Gardens and Cats* . . .

Flower painting and the gardening which supports it are so much part of Elizabeth Blackadder's life and art now that it is difficult to imagine that there was a time when this was not so. Of course her interest in flowers goes back to her childhood love of botany and to confirm this one of her notebooks full of botanical studies from her schooldays turned up quite recently. Flowers do appear in her still-lifes over the years too, in *Flowers on a Greek Rug* as early as 1963, for instance,

but they are treated like the other objects, not sharply described but merged into the wider composition. But the absence of any significant reflection of this interest in her painting was perhaps more a matter of opportunity than inclination, though she was also very aware that incorporating the direct observation of flowers into her art would not be an easy thing to do. This was why the example of Mondrian was so important. He showed that it was at least possible to do this. And in fact when they went to America, the Houstons had already had a garden for a number of years, but flowers did not appear significantly in Elizabeth's work till the 1970s, after they had moved to their present home in 1975.

Their first garden was in Queen's Crescent when they moved from their flat in London Street in 1963. It was relatively small. The occasional flower drawing, such as a large and powerful pen and ink drawing of *Lilies* from 1966 (Plate 18), marks Elizabeth's developing interest in the garden, but the appearance of more ambitious flower painting ten years later certainly reflects the move to Fountainhall Road where the Houstons not only had and still do have a large and magnificent garden, but also at first had a gardener, Danny Brown, who came with the house. Danny, she remembers, did not trust the skills of the new owners of his garden. 'He thought we were hopeless', she says. But even if they were, they soon learnt from him and started to create in their garden a brilliant display of vivid and exotic flowers. A few paintings record the flowers from the first years of this new garden, and when Elizabeth did start to paint flowers in earnest a little later, the tulips and the irises they planted were to become one of her favourite subjects.

Along with the garden, their cats became an increasingly important part of the Houston's life. Like the flowers they did not become a favourite subject for Elizabeth till the mid-1970s, though there were occasional cat pictures before that such as *Cat on a Rug* from 1969. But that picture is quite loosely painted and the cat in it is not sharply observed as are the cats in her later drawings and paintings of them. The Houstons' had acquired their first cat, a present from David Michie, when they moved to Queen's Crescent. Handsome, black and half-Siamese, called Couscous, it was, says Elizabeth, very wild and eventually it left them. Couscous was the cat in the 1969 painting and it has been followed by a good many others. A particular favourite was a tortoiseshell cat, called Coco after Coco Chanel, who appears in a good many paintings from the late 1970s onwards, often in the company of a black cat called Sophie. Coco was a present from the potter Katie Horseman who had a passion for tortoiseshell cats.

But with cats as with flowers, though they became so much part of her life, from the start Elizabeth was conscious of the difficulty of painting them. Not just the technical difficulty, but the risk: incorporating them into her painting was at first perhaps a bit like acting with children. They are too easily charming. Aware of this, she describes how she spent time studying them much as she did flowers, and drawing them in an analytical way. She had already approached this in a number of paintings and drawings of zoo animals – monkeys, zebras and the like – that she had done in the previous years. There are drawings from the early 1970s onwards that record the extension of this process to the study of cats (Plates 19, 20, 21 and 22).

18 (facing page)
Lilies
1966 Pen and ink
24 x 22 in (61 x 56 cm)

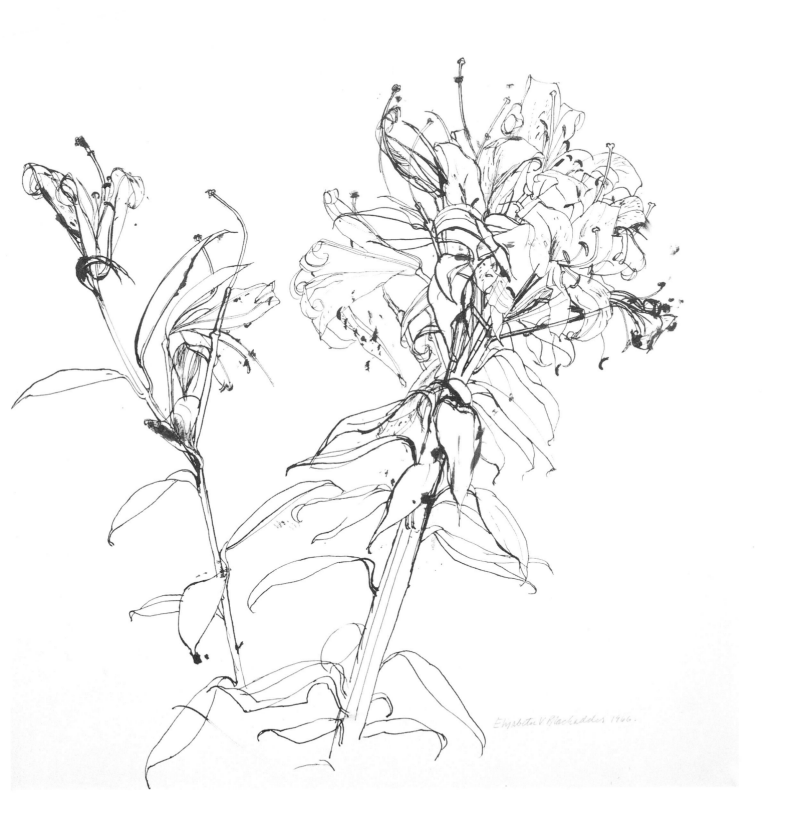

Elizabeth V Blackadder 1966.

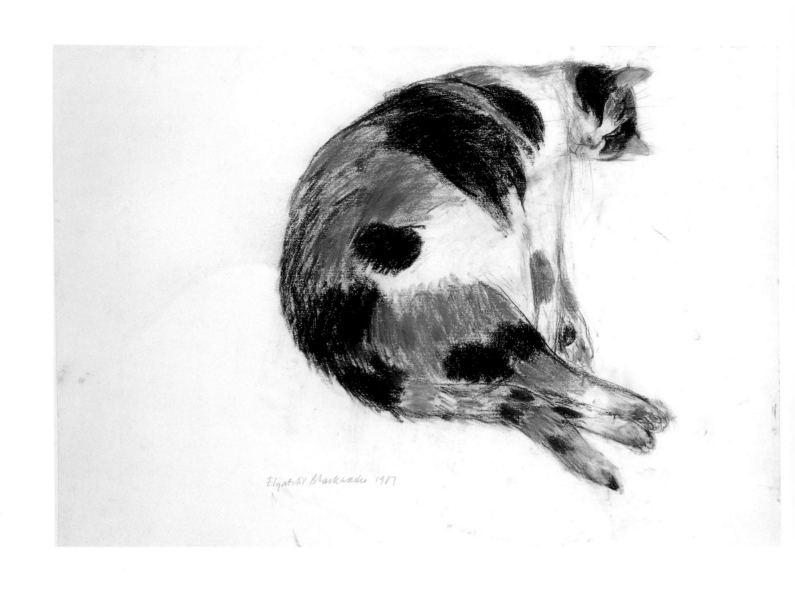

Elizabeth Blackadder 1987

19 *Coco*
1988 Pastel 16³/₄ x 23³/₄ in (43 x 60 cm)

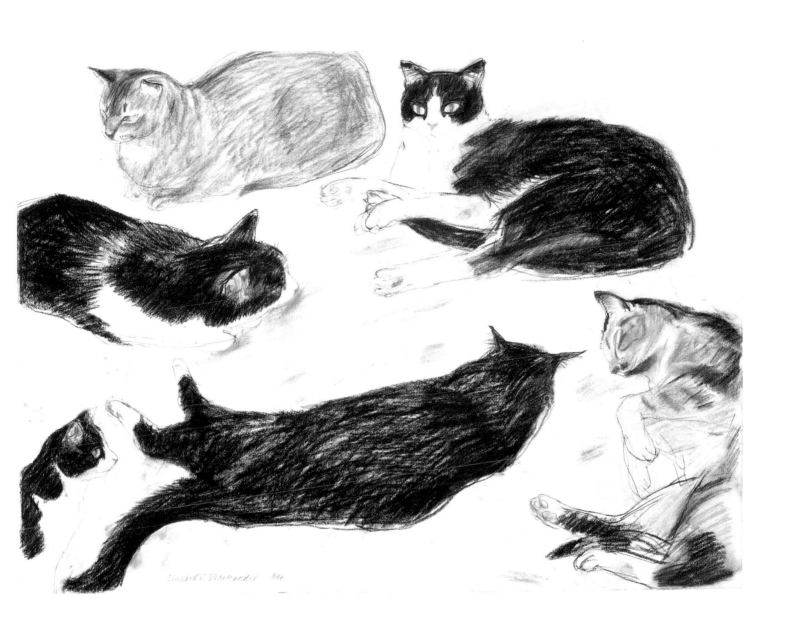

20 *Studies of Cats*
1996 Pastel, 20 x 26^{1}/$_{2}$ in (51 x 67 cm)

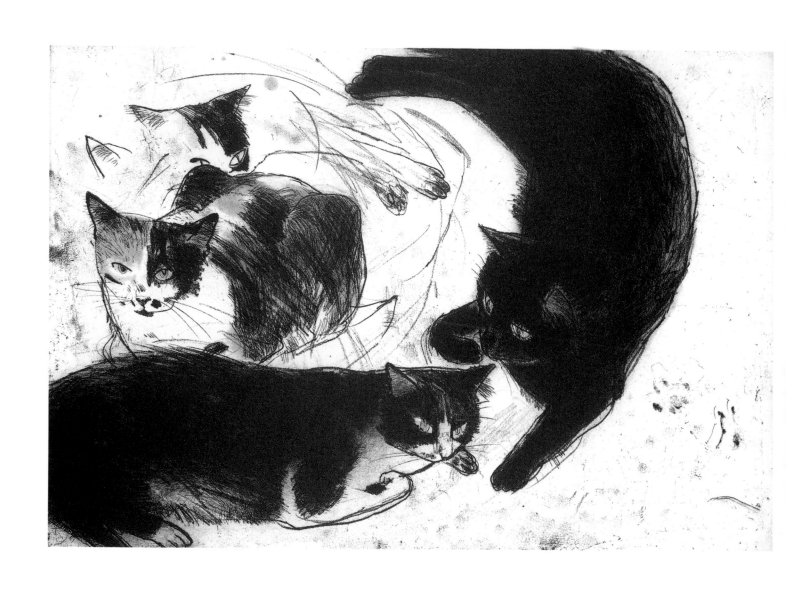

21 *Studies of Cats*
1994 Etching/Aquatint 16 x 23 in (41 x 58 cm)

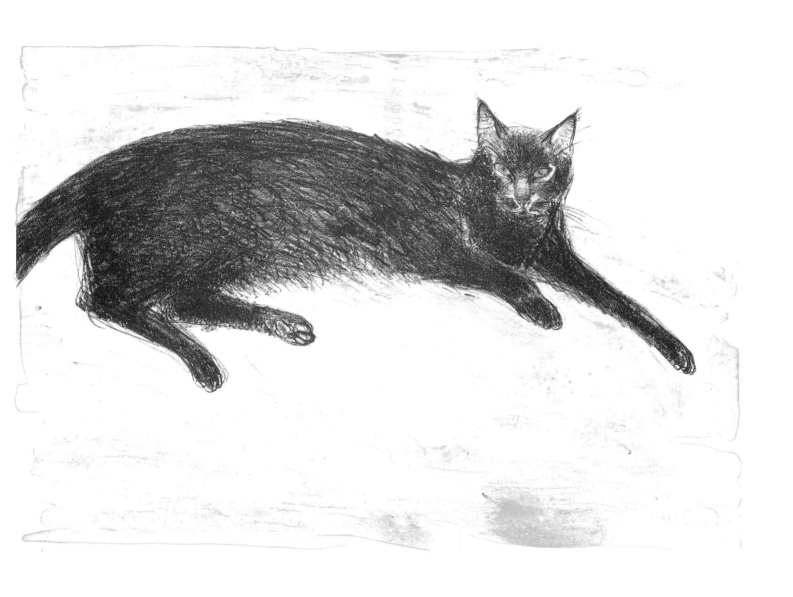

22 *Black Cat*
1980 Lithograph 16 x 22 in (41 x 56 cm)

Beautiful drawings, worthy of an Old Master and as strongly seen as her earlier drawings of buildings, they have an unsentimental and inquiring line that grants its full and independent existence to the animal. There is no creeping anthropomorphism here. The seriousness of the undertaking was a gesture of respect, typical of her approach, not just to cats of course, but to her whole awareness of the world and the independent life of the things in it that she incorporated into her paintings. As well as studying cats from the life, she also studied other artists' treatment of them. Steinlen, Manet and Bonnard are among those she remembers; and of course the way that cats eventually took their place in her painting, just as they did in her domestic world, is closest of all to Bonnard.

Flowers and cats begin to appear together in her paintings in the late 1970s. They are both closely observed. The cats are an animated extension of the objects she had always painted, those objects that seem to assume their own position in the composition with so little fuss. The cats do the same with their characteristic, natural independence. They look as though they had walked across the composition and sat down where it suited them. Indeed there is one picture that she remembers started with one cat and ended with three as two others joined the first! Early examples of this new and very distinctive kind of composition are a lovely small watercolour of Coco, the tortoiseshell cat, sitting beside a lily from 1978, or another of a black cat stretched out among several vases of flowers (Plate 23). In a big watercolour from 1978, Coco and the black cat, Sophie, are sitting among three or four vases of flowers, a fan and several pieces of cloth, all scattered as though at random across the sheet of paper. The background of the paper is touched in places with a light wash, but mostly it becomes space simply because of the presence of the cats, the flowers and the objects that inhabit it. Then in 1979 she made a lithograph for Gillian Raffles of these two cats among flowers (Plate 24). Its publication helped promote the popularity of this kind of image, though it must be said that its enormous success has perhaps sometimes obscured the seriousness of the art from which it grew and of which it remains part.

Like the cats, the flowers in these pictures are beautifully observed, but the close study of flowers took time and as with the cats, it really involved a new kind of exercise. It was as intense as her study of buildings in Italy twenty years before and although her still-life had always incorporated things seen in high focus and so her new interest was a natural extension of it, painting flowers still demanded a new kind of pictorial language. From the start, to achieve this she worked in watercolour, though this was also partly of necessity. Illness and convalescence in the late 1970s meant that she could not undertake large canvases and had to paint whatever was at hand, and the garden was right there. But the delicacy, subtlety and brilliance of watercolour also meant that it was the only medium for what she wanted to do, at least until she began to make prints of flowers a few years later and it is only very recently that flowers have become a significant motif in her oil painting.

There are sketchbooks full of wild flowers that she painted in the summers of 1978 and 1979 sitting on a riverbank while John was fishing which are jewels of

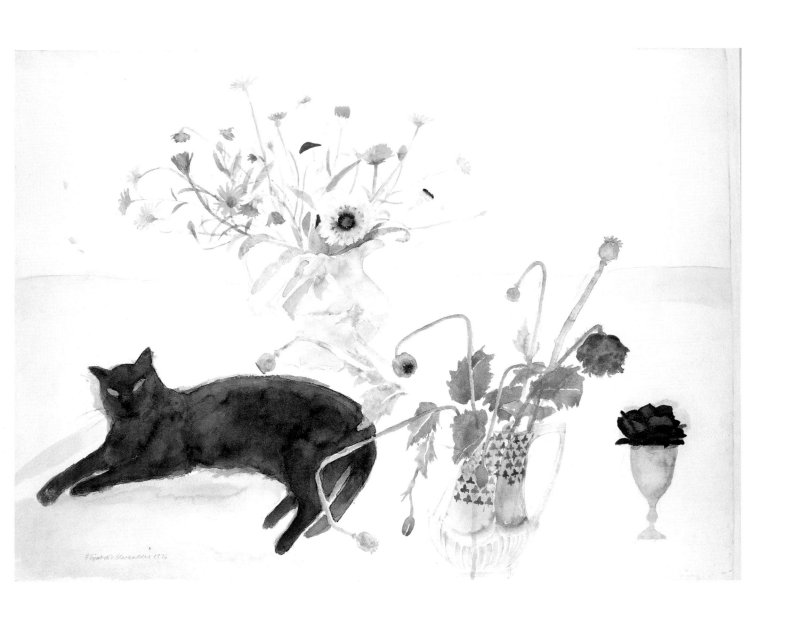

23 *Cat and Flowers*
1976 Watercolour 22$^{1}/_{2}$ x 30 in (57 x 76 cm)

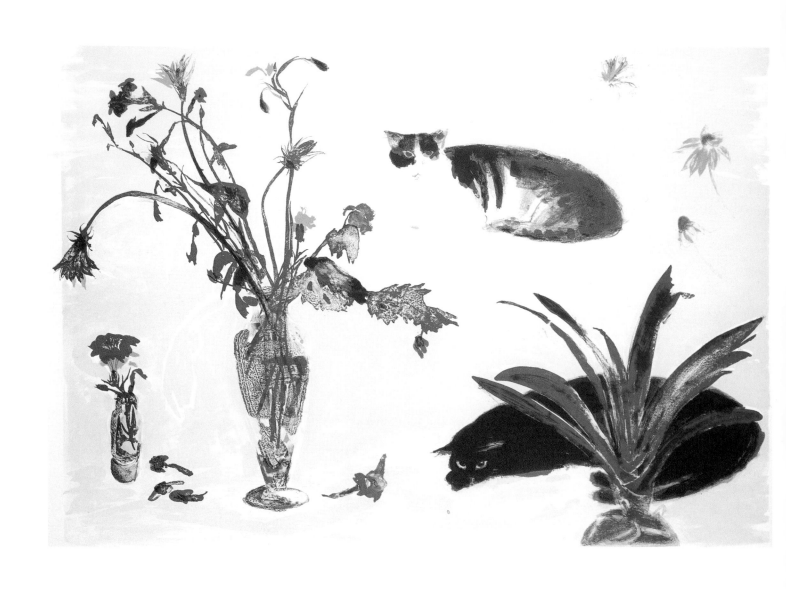

24 *Cats and Flowers*
1979-80 Lithograph 23 x 31 in (58 x 79 cm)

25a *Pages from a Sketchbook,*
Rosebay Willowherb and
Red Campion
1970s Pencil drawing
5^1/$_2$ x 4^1/$_2$ in (14 x 11 cm)

25b *Pages from a Sketchbook,*
Echium and Hydrangea
1970s Watercolour
5^1/$_2$ x 4^1/$_2$ (14 x 11 cm)

26 *Tulips*
1998 Watercolour 28 x 41 in (71 x 104 cm)

intense observation. A single study on each small page, delicate as a pressed flower, she achieves a synthesis between drawing and the marks of her brush so eloquent that we are hardly conscious of it (Plate 25). Extending this approach, among the early compositions with flowers are several brilliant, small water-colours. One is of the exotic tulips that they planted early on. Purple, almost black and shot with yellow, the feathered petals seem almost animated there is so much energy in them and though there are only four blooms, three in a jug, one in a glass, they fill the composition. Another is of full-blown poppy blooms (Plate 27). The flowers again fill the composition. They are closely observed, but as the same time intensely felt and vivid images.

These small flower paintings are also very free, almost like her landscapes. The large full sheet paintings of irises, lilies, poppies and tulips that have become so familiar are differently painted and organised, and around 1979 she began delib-erately to paint these in an idiom that was close to classical botanical painting, ranging the flowers like specimens across the paper (Plates 26, 27 and 28), adding a study of a detached flower head alongside a group of long-stemmed blooms, or writing the Latin names (Plate 31) beside them. Indeed around that time she introduced a course in painting from plants to her teaching at the College of Art. It was held in the Botanic Garden in collaboration with members of the staff there, and in 1979 she also collaborated with Dr Brinsley Burbidge, of the Royal Botanic Garden in Edinburgh, on the preparation of an exhibition of contem-porary botanical painting, *The Plant*, held in the Scottish Arts Council's new Trav-elling Gallery that year. These activities continued a longstanding connection between art and botany. Harold Fletcher, Keeper of the Botanic Garden, was a notable art collector. He had also been chairman of the governors of the College of Art and it was on his initiative that Inverleith House, formerly the residence of the Keeper of the Garden, became the first home of the Scottish National Gallery of Modern Art.

Since then Elizabeth's flower painting has become one of the most distinctive branches of her art and in recent years she has added wonderful paintings of fruit using the same technique. She paints on Whatman or French Arches paper. Both are hot pressed with a hard, non-absorbent surface so the paint stays on the surface and dries there. Looking at the scarlet of a tulip petal or the intense dark blue of an iris, it is possible to see clearly how the water carrying the pigment has dried allowing it to form its own patterns that mimic the patterns of colour in the flower. Somehow she controls the liquid paint so that it matches faithfully these patterns. The edges of these passages of colour also describe exactly the edges of the petals. Using this technique their outline is also the outline of the area of wash. As the liq-uid wash dries, surface tension creates a tiny lacy pattern round its edge which somehow, as by magic, matches the delicate outline of the flower. Nature is the artist's ally in describing this natural beauty. Then the white paper beneath the paint shines through to give its full saturated brilliance to the colour. Yet it is true to say that the artist does all this with such freedom that the fluent movements of her hand seem to echo the energy that drives the flower's growth and that distils

27 *Shirley Poppies in a Jug*
1983 Watercolour 22 x 31 in (56 x 79 cm)

30 *Strelitzia, Ginger and Passion Fruit*
1996 Watercolour 22 x 31 in (56 x 79 cm)

29 (left) *Blue and Purple Irises*
1998 Watercolour 30 x 20¹/₂ in (76 x 52 cm)

Elizabeth Blackadder 1994 V. CHIENGMAI BLUE VIBOON

the brilliant colour of its petals (Plates 29 and 30).

In spite of this brilliance some admirers of her art objected that she was being too botanical. Certainly until recently, her flower painting has seemed an almost separate branch of her art, always in watercolour and painted on hard surfaced, hot pressed paper so that the colour is more brilliant and the painting more precise. But this difference was largely an illusion for there is a close affinity between these botanical compositions and the way her still-life painting was to evolve, especially in watercolour. Indeed there are a good many flower paintings in which she takes a much freer approach, not neglecting the sharp observation of the flowers, but handling it in a slightly more summary way and incorporating them into a more open kind of composition.

In 1980, alongside tulips, irises, lilies and other garden flowers, orchids appeared in her painting for the first time. Her first orchid painting, *Orchid and Black Cat* (1980), was of a plant that she had borrowed from a friend who collected Scottish paintings and was a cultivator of orchids. Elizabeth was terrified that she would not be able to keep it alive, but soon she grew more confident and the series of prints of orchids that she made only a few years later with Glasgow Print Studio is not only one of her finest print productions, but also testimony to the depth of her knowledge of these strange exotic plants (Plate 31).

She was of course continuing to paint landscape throughout this period as she had always done, working from drawings, or very often painting on the spot in watercolour. After the early 1960s for quite some time she produced relatively few large oil landscapes, but her watercolours continued throughout the period. They were almost always the result of a journey, whether within Scotland or abroad. As well as the paintings that resulted from their regular visits to France, there are watercolours of the North East, for instance, done in company with Henderson Blyth who took the Houstons to places like Gardenstown that he had visited with Gillies. There are also some very fine, free and broadly painted large watercolours of Skye that followed a visit there in 1965 (Plate 32). They visited Skye again in 1970, and in 1974 and 1975 they took a cottage on Harris. There are a number of powerful watercolours of Harris, *Peat Cuttings* (1976, Plate 33), for instance, where the black lines of the peat banks are like lines of drawing against the dark hillside, or *Hillside with Sheep* from the same year with a line of sheep winding along the crest of a hill, animating the contour in an eccentric way. In 1977, two years after their second visit, the inspiration of Harris also produced *Scalpay, looking towards the Shiant Islands* (Plate 34), one of her finest oil landscapes of the period. Patches of bright green among black rocks, two cows, a grey sea, a white lighthouse on a distant rocky headland, a passing steamer on the horizon and a glimmer of pink in the sky; it is an austere and magnificent picture.

Her watercolour landscapes almost look like a relaxation, however. Much more loosely structured and directly painted than her still-life painting, as they look back to her own earlier work and even to Gillies and the older generation, they also remind us of how her still-life painting had evolved from that tradition. But if in a way she was still, like Gillies, deploying a different vocabulary for landscape from

31 (facing page)
Orchid, Blue Vanda
1994
Watercolour
30 x 22¹/₂ in
(76 x 57 cm)

32 *Beach, Elgol, Isle of Skye*
1965 Watercolour 27^1/$_2$ x 40 in (70 x 102 cm)

33 *Peat Cuttings, Isle of Harris*
1976 Watercolour 26¹/₂ x 40¹/₂ in (67 x 103 cm)

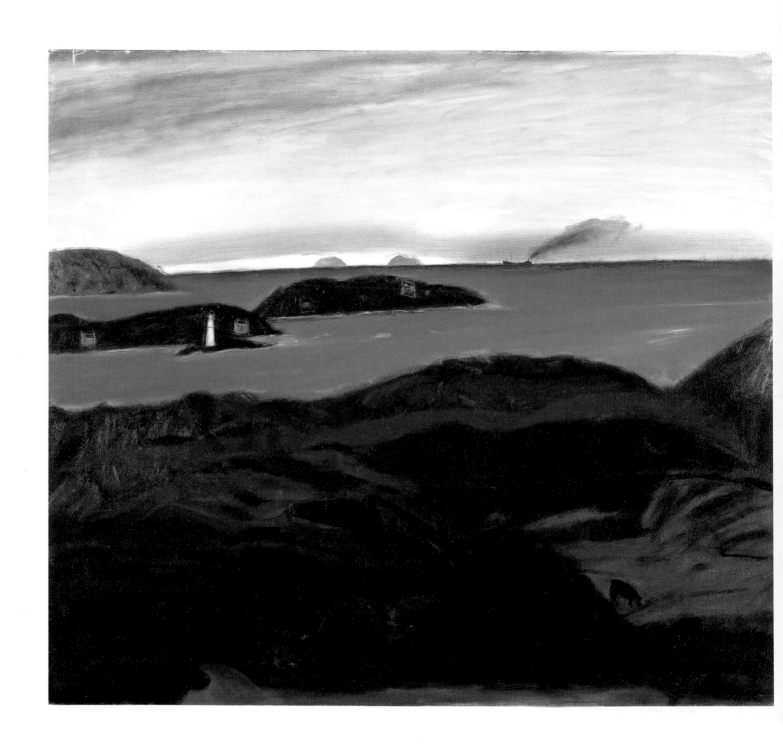

34 *Scalpay, Looking towards the Shiant Islands*
1977 Oil on canvas 36 x 40 in (91 x 102 cm)

the one she used for still-life, this was more apparent in her watercolours than in her occasional landscapes painted in oil. These are as spare as her still-life paintings. In them she seems more willing to treat space the way she does in her still-lifes than she does painting landscape in watercolour, moving in and out of focus and letting brushmarks become incidents in the picture field. *Garden onto the Mediterranean* (1966) is a beautiful and very simple landscape in the South of France, for instance. Most of the picture is sea, pale blue, rising to the paler blue of the sky at the horizon; a narrow band of detail runs diagonally across the bottom, the coastline, some fields and trees, but scarcely defined as though the sea and sky alone were the real subject.

The Church at Ericeira, a Portuguese picture from 1969, is another good example of this approach. It follows on from earlier paintings of Portuguese buildings with their decoration in pure cobalt blue. Here the blue painting on the church is of the same intensity as the sky and merges with it. The sky's intense blue seems to bleed into the red of the earth. The white painted walls of the church reflect the sky's colour too, so the building seems to float off into the sky. But this is balanced by the fact that it is the most sharply focused part of the painting. As in her still-lifes, or in the earlier watercolour of Pistoia which is rather similar in composition, the rest of the picture, though not exactly subordinate to it, supports this part that has most attracted her interest. With its tipped space and summarily brushed details of cars, palm trees and the like, this treatment might seem highly conventional, as though the building had been hijacked for the purpose of the painting. In fact it is a way of painting that is closely analogous to the way we see, not in terms of optics, not analytically, but subjectively, as we know things by seeing them; and of course by remembering them.

Teaching at Edinburgh College of Art, Elizabeth also had access to the Life Room and continued to do life studies, incisive, wiry drawings that show that the power of her early draughtsmanship had not faded. Occasionally too she turned these into paintings, a wild-looking red-haired girl isolated in a box-like space reminiscent of Francis Bacon, for instance, or a dejected young man in profile sitting on a stool. She also painted a very fine *Self-Portrait in an Indian Jacket* (1973-4) that is somewhat similar in structure to these. There is a cat with her and though Elizabeth is seated well back in the composition, facing us, for a moment she seems to step out into the foreground of her art, not just because of her image, but because of the way that through it she identifies her place in the whole process. The point of the picture, she says, was the embroidered jacket which she had just acquired and she is sitting on a chair on a Spanish rug. There is a bedspread draped behind her. For a moment she is like one of the objects in her own still-life, just like the cat that accompanies her, but correspondingly by her presence she also reminds us of just how personal all those things are.

. . . *Japanese Paper: a new departure* . . .

In 1981 a major retrospective of Elizabeth's work was held at the Fruitmarket Gallery in Edinburgh. This recognition followed her election as a Royal Scottish Academician in 1971 and as a Royal Academician in 1976. The latter was a signal honour as there were never many who were full members of both Academies and she was the first woman to be elected by both. The retrospective exhibition was selected by William Packer. Over a hundred works were shown, pretty well spread out over her career though with a rather greater emphasis on the 1970s than the earlier years.

In the catalogue too, though it was not so obvious in the exhibition, there is an unexpected stress on drawing. Elizabeth always has been a remarkable draughts-man, and considering the way she uses drawing as an aide-memoire, but also a refining device for her memory, this was perhaps compatible with the impression that one gets now looking back over her work as a whole, for memory seems to be the key. She constantly works from memory. She brings things back from travels that are a physical form of memory and builds her paintings around them. The increasingly freely constructed picture fields that she uses are a kind of pictorial equivalent to that intangible 'space' in the mind that memory inhabits and where events and objects assume a relationship to each other through a complex web of associations that, even though they may not bear rational analysis, are nevertheless real. They are intuitively understood and no less powerfully felt because existing only in the mind. There are of course important precedents for this approach in Bonnard, Matisse, Whistler and beyond. But it is not surprising that Elizabeth's own approach to this kind of metaphor for mental space should have led her to find an increasingly close affinity with Japanese painting. For Japanese artists space was never a kind of separate, abstract armature supporting the structure in a picture, or somehow containing the objects within it. It was instead part of a much more fluidly conceived continuum that embraced the objects described, the inter-vals between them, and our experience of the reality that indivisibly we share with them.

This increased interest in oriental art became apparent in Elizabeth's art at much the same time as the retrospective exhibition which slightly ironically came at a moment of quite rapid evolution in her work. She had really only begun her flower painting in the previous couple of years. One of the early classics in the genre shown there was *Amaryllis and Crown Imperial* (Plate 35) painted in 1979. The cover of the retrospective catalogue, *Still-Life, Gold and White* from 1980 (Plate 36), also represented another very important recent development in her work, the still-life on Japanese paper. If the space in her still-life painting had always been in a sense 'Japanese' or at least had had an unconscious affinity with Japanese painting, the most significant new departure in her art was Japanese in this more practical way.

It was in the mid-1970s that she started using Japanese paper successfully. The kind of paper involved is the unsized watercolour paper that Japanese brush

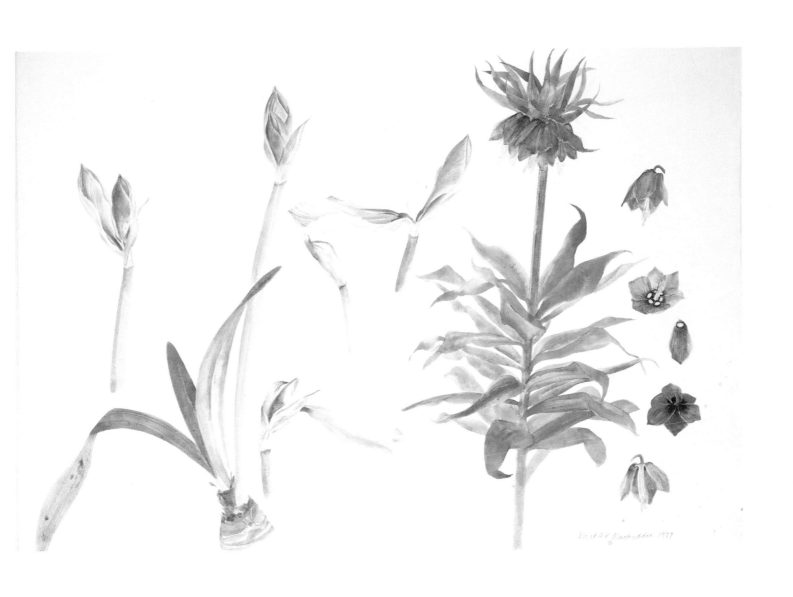

35 *Amaryllis and Crown Imperial*
1979 Watercolour 22¹/₂ x 31 in (57 x 79cm)

painters use. This paper has an open, woven texture that acts like a sponge. Paint or ink goes straight into the weave and does not sit on the surface. The paper is designed for brush drawing and calligraphy where the principal characteristic and skill is the way in which the artist puts down each stroke without hesitation or afterthought. The mark on the paper echoes precisely the movement of his hand and the weight of ink with which he has loaded his brush. There is no opportunity for second thoughts, nor for the kind of brushing to spread and shape the mark that is the normal mode of Western painting. This paper usually has a very marked texture too, or perhaps more accurately a visible structure. The pulp it is made of is left deliberately coarse so that the fibre is clearly visible and little pieces of material suspended in the mesh of the paper give it a positive surface.

John had got hold of some of this paper back in the late 1960s and had then obtained a big supply of it in Chicago. He had used it with great success in the early 1970s. A series of watercolours done in Harris for instance exploits its qualities and the kind of saturated colour that it offers to dramatic effect. Elizabeth tried it, but found it difficult, or perhaps simply it did not at first suit her need; but the increasingly open structure of her watercolour painting led her in this direction. There are pictures using Japanese paper from as early as 1970-71. A *Still-Life with a Fan* painted then has a piece of Japanese paper collaged onto it and then painted, but *Still-Life with Flower Heads* (1974, Plate 37) is one of the earliest really successful examples of her use of this medium and it was not painted till three years later. Two feet by three, it is a simple composition on a paper with strongly marked fleck pattern. At the centre, and the dominant feature, is a complex chequerboard, softly coloured, its squares further subdivided into triangles in a way that is reminiscent of Paul Klee. A loosely brushed framing rectangle could be a remote, residual memory of a table top. The flower heads of the title, three tulips, together with an agate and one or two other objects, are loosely arranged along the bottom. But she quickly began to be more ambitious with this way of painting. In *Still-Life with Easter Eggs*, for instance, painted in 1976 or *Still-Life with Toys* (1978/9), she is constructing a composition within a space as she did in her oil paintings, minimally, but visibly. A light grey rectangle sits against a dark grey one, the implied table that was an integral part of so much of her still-life painting. The principal incident in the composition, a kind of stack of abstracted objects, is set against this on a vertical axis.

There is still a close parallel between a painting like this and her contemporary still-life paintings using conventional watercolour and paper from which these new pictures evolve naturally, *Still-Life with Hearts*, for instance, or *Still-Life with an Indian Purse*, but the bright colour and sharpness of focus in these oil paintings does give a very different effect. Though she did occasionally use sized, and therefore less absorbent Japanese paper, in the lovely *Table and Abacus* (1980) for instance, in the next few years her command of the unique, absorbent qualities of the unsized paper evolved rapidly. In *Still-Life with Black Fish* (1978, Plate 38) the eponymous fish is brushed into the paper with complete confidence and literally swims there, suspended in the paper's space as though in water. The pattern of the

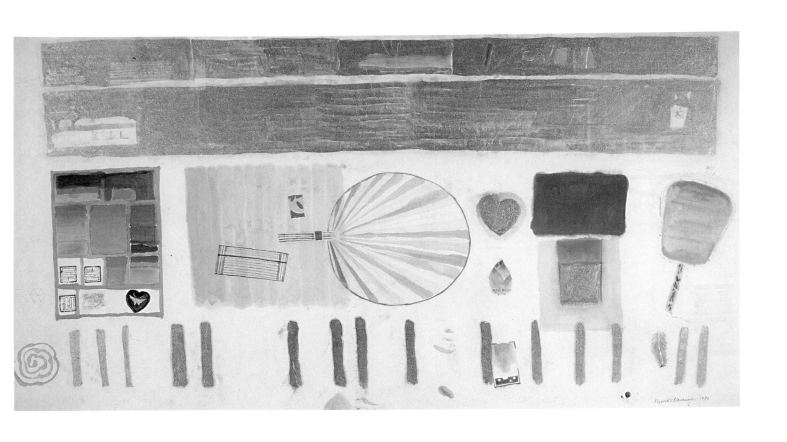

36 *Still-Life, Gold and White*
1980 Watercolour 27¹/₂ x 52 in (70 x 132 cm)

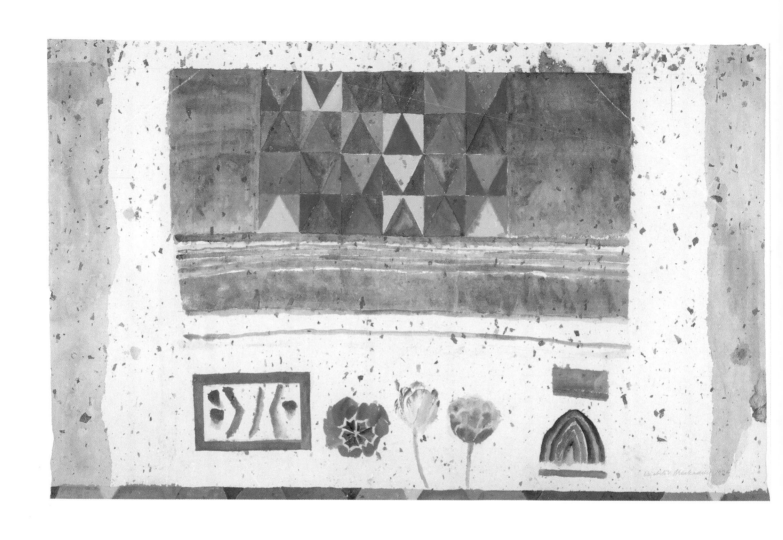

37 *Still-Life with Flower Heads*
1974 24 x 35 in (61 x 89 cm)

38 *Still-Life with Black Fish*
1978 Watercolour 23¹/₂ x 35¹/₂ in (59.5 x 90 cm)

fragments of material in the paper, seeming to move like the fish, gives the picture a visible flow. Frequently in these pictures long-shaped objects, brushes, chopsticks, and the like, tend to support this impression by being arranged predominantly along the line of this movement. They waver in its flow like weed in a stream. And this of course is the beauty of these paintings. Because of the way ink and paint and objects sit in the texture of the paper, the picture becomes an animated space. It is a place into which things can be gathered as the mind moves over them.

There is also another very important development visible in *Still-life with Black Fish*. Clearly inspired by the way the gold and silver are used in Japanese screen painting, Elizabeth began to use first gold paint and then gold leaf in these still-lifes. The gold paint brushed onto the surface of the paper is partly absorbed by it, but gold leaf sits on the surface. The effect is very beautiful. It enriches the picture as an object, adding something to the sense that this is a cherished vision, a celebration. It might even be another memory of the Byzantine art of her student days, the glimmering gold of the mosaics. But it also serves another purpose closely akin to the way it is used by the painters of the Japanese screens that were her primary inspiration. They deploy it in blocks the shape and the size of the individual sheets of gold leaf. Its edges clearly defined against the supporting paper, each sheet of gold becomes a surface like the reflective surface of a pool of water. It is clearly marked, a plane in space established by reflected light, yet it also implies the depth that lies beneath it. Here that depth is the paper within which the objects are suspended: the place where that black fish swims. It is not surprising that fishponds were later to become such an important theme in her oil painting.

There is therefore no break in the continuity of the development of her painting here. It is simply that the new medium allows her to achieve her objectives with an even greater elegance and simplicity than hitherto. There are of course things she cannot do with Japanese paper. Although there are occasional flowers in these still-lifes, a wonderful bunch of anemones for instance, or a single camellia, mostly what they contain is simple objects, or brush marks there for their own sake; later she adds little pieces of collage, all incidents in the picture's continuum. In one beautiful example a black sash curls through the picture space. It is as though it was a brush mark detached, turned into a garment and then reincorporated into a painting again, such is the eloquence of this exchange between real and imagined, painted and observed.

. . . *Journeys to Japan* . . .

It was a logical development of this approach that she turned to a new pictorial form, a long narrow horizontal made by joining two or more sheets of Japanese paper together imitating the layout of an Oriental scroll, the alternative form to screen painting in the East. But though Elizabeth experimented with this form as early as 1982 in a series of paintings that were exhibited in Canada that year, she was able to treat it with new confidence after her first visit to Japan. This was in

1985. It was the first time that the College of Art had had a three week vacation at Easter. John and Elizabeth had had the ambition to go to Japan for some time. Indeed it was almost an imperative for Elizabeth as her art, following its own independent route had come closer and closer to the spirit of Japanese painting, and having been advised against Japan in the summer heat, they saw this Easter break as their opportunity. In the autumn of 1986 they made a second more extended visit. Elizabeth had retired from teaching in the summer of that year. John was given a sabbatical by the College of Art and so they were able to stay for five weeks. On both occasions they travelled widely, as far west as Nagasaki and as far north as Akita.

Beautiful examples of the painting that Elizabeth did in response to the stimulus of her first encounter with Japan are *Still-Life Kurashiki* (1985, Plate 39) and *Hiragaya Still-Life* (1985), both painted immediately after her return from their first visit. The shape of these pictures, more than twice as long as they are high, is again close to scroll painting. The shape of a composition may seem unimportant, but the form of a scroll does not just reflect the way it is read. It implies a kind of visual flow not bound by framing verticals, but flexible. It is punctuated by events along its length, but they do not divide it up, rather they link different passages together and so maintain the flow of the composition. It was for this reason that William Blake contrasted the form of the scroll with this inherent fluency and freedom to what he saw as the life-denying discipline of the bound book divided into separate, numbered pages. His was a purely metaphoric approach, the scroll as a symbol of imaginative freedom, the book as a symbol of oppressive law, but it captures the essentially fluid character of the scroll. Elizabeth's approach is more practical and relates to the way she actually paints, but it also reflects her response to the same characteristics.

The result was a series of long, flowing compositions with the proportions of a scroll. But though the metaphor is less tendentious than Blake, we should not overlook the fact that there still is a metaphor in these beautiful paintings. It is a metaphor for memory and the way the mind can hold and cherish images, examine them, invest them with significance born of association, put them to one side, all in the same mind-space. This had been evolving in her work since those first still-lifes painted twenty years before, but the mind-space that she painted then, beautiful and poetic as it was, was nevertheless still essentially static. Now it has become fluid, a progression in time moving from incident to incident in the long flow of these scroll-like compositions (Plate 44).

On both visits to Japan they saw a great deal, but they also made a special point of visiting gardens. This reflected their own interest in gardening, but also for Elizabeth it related very closely to her painting, not directly perhaps, at least at this date in the subject matter, but in a way that had more to do with a deeper affinity. Classical Japanese gardens are an art form where intuition is cultivated as much as plants. This is seen at its simplest and most austere in the great Zen dry gardens like the Ryoan Garden in Kyoto which John and Elizabeth visited on their first trip. Rocks are arranged in a field of raked sand. The rocks are carefully chosen for

39 *Still-Life Kurashiki*
1985 Watercolour 25¹/₂ x 58 in (65 x 147 cm)

their individual form and their relationships to one another. The lines in the sand articulate the spaces between them and like a great brush drawing, rocks and space together have a unity in which everything plays a part. But in contrast to Western traditions of geometry, symmetry and calculated order even in informal gardening, the rightness of these relationships is purely intuitive. There are no rules or axioms. The garden is a projection of the Zen vision of order as indivisible from our experience of it.

This is also how Elizabeth's painting works. But its affinity with this Japanese vision of intuitive order is not just a personal idiosyncrasy. It is a point at which her instincts as an artist stem from concerns at the very heart of the Western tradition. Western painting is conventionally structured on a framework similar to literary narrative: the formal structures of space and depth, the intellectual constructions of perspective even, are the assumptions of ordered composition, like the continuities of time in narrative. But since the eighteenth century modern art has evolved from the philosophical proposition formulated here in Scotland by Thomas Reid, developing arguments set out by Hume, that intuition not intellect is our primary mode of understanding and that intuition does not separate our understanding into separate compartments of time and space. We experience them as indivisible.

It was subsequently because of this understanding of the importance of intuitive knowledge that Western artists first turned to Japanese art in the late nineteenth century, recognising its affinity with this approach, and many of the greatest artists continued to find inspiration there in the twentieth. There they found an idea of pictorial space as concerned with what unites things rather than what divides them: an art where space is part of the experience, not the external frame in which it is set as traditionally it always was in Western art. There such structures reflected one of the fundamental *a priori* of Western thought, the distinction between solid and void, between space and matter, a distinction that was eventually confounded by the discoveries of atomic physics, just as it was by art, and at much the same time. In trying to describe this, much modern painting has been concerned with a search for a kind of pictorial space that does not reflect the structure of the external world so much as what might be called the whole shape of consciousness. Here Elizabeth Blackadder produces her own unique response to that concern taking her place in a long tradition that reaches back to the beginnings of Modernism.

But this relationship with Japan was also a very practical one which had a more immediate reflection in her painting. From the start of her interest in the Far East, it was not only the paper these pictures were painted on, but the objects represented in them that were oriental in origin, Indian first, then increasingly Chinese and Japanese. Reflecting her increasing curiosity about the Far East, Elizabeth collected Chinese things from various sources and they seem to be identified as oriental by name for the first time in *Chinese Still-Life* painted in 1977. In the picture a Chinese basket with one or two other objects and a box that Elizabeth had decorated herself are sitting on a chest. A bright coloured printed card is drifting off in an unattached kind of way that was to become typical of the organisation of this

kind of picture. In Japan the Houstons bought whole new collections of things, ranging from painting materials, through little ceramic chop-stick stands, paint brushes, seals, kimonos even, and ephemera of all kinds; a huge variety of objects, some notable for their brilliant colour and decoration like richly coloured paper wallets, or playing cards, others for their unusual shape like paperweights and kites. All of these things and many more appear in the paintings that she did after her return. Sometimes they are collaged onto the surface, too, postcards, pieces of wrapping paper, little pieces of Japanese painted script, or in one picture two post-cards which had pressed flowers embedded in the weave of the paper. Seals are stamped on the surface of her pictures as they are on Japanese prints. She had also done this earlier in pictures like *Still- Life with an Indian Purse* for they had already bought seals in London before they went to Japan, and she used them for their appearance without knowing what they meant.

The result of these first visits to Japan is a new vocabulary of objects and a greater brilliance and complexity in her painting, but not at this stage any radically new departure in the way she approached it. As so often this took time to develop. To Wordsworth's famous definition of poetry as 'emotion recollected in tranquillity', with her art you add 'and refined by memory'. But before returning to consider the wider impact of Japan on her painting in the early 1990s, another important development had taken place in the late 1980s. Over the years since those early lithographs with Harley Brothers and the Curwen Press Elizabeth had made occasional prints, but in 1985 she began a working relationship with Glasgow Print Studios that has since then proved enormously productive. This followed an invitation from John McKechnie, director of the Studios, to come and make an etching. She had not made one since college, but with McKechnie's help she went straight into it to produce a striking print of hibiscus flowers and cats.

. . . *Printmaking in Glasgow* . . .

Since then she has made over seventy prints with the Print Studios. She worked at first with John McKechnie, but subsequently most of her etchings were made with Stuart Duffin. Later she also worked on screen prints with Norman Mathieson. The whole series of her prints was exhibited at the Print Studios early in 1998 and made an impressive display, demonstrating that she is clearly in the first rank as a print-maker. These Glasgow prints are mostly etchings, though they also included woodcuts and screen prints. In some etchings she uses traditional etching techniques, cats in aquatint, rich and black as their fur, or small landscapes drawn with a spiky, inquiring line, but mostly in these prints she uses colour etching to create images of flowers of astonishing richness and brilliance. The line is drawn and etched and its wiry intensity gives life to the flower. Then colour is dabbed on to the plate (a process called *à la poupée* because to apply the colour a little bag is used that looks like a rag doll, or in French a *poupée*). This dabbing gives a soft effect which contrasts with the sharpness of the line and makes the whole image very

40 *Orchid Phalaenopsis – Antarctica*
1992 Etching/Aquatint 12 x 14 in (30 x 38 cm)

rich. Many of these flower prints are actual size, *Fritillaria Imperialis*, for instance, an astonishing green and yellow crown of flowers on a tall stem two feet high in the middle of a sheet of paper. And she made a brilliant portfolio of ten different orchids that are studies in character. Outside that sequence, there was also a moth orchid (Plate 40), like a fluttering cloud of moths, and these are all portraits of the flowers as much as they are botanical descriptions, accurate though they undoubtedly are.

Another new departure in the late 1980s was the production of formal portraits of people. Hitherto she had confined herself mostly to self-portraits and one or two portraits of John, but some of her figure paintings are very strongly characterised and the commission from the Scottish National Portrait Gallery in 1987 to paint children's author Molly Hunter did not seem too radical a departure from her usual practice. She followed the success of this portrait with one of the doyenne of Scottish letters, Naomi Mitchison, that was painted not to commission, but at the suggestion of Gillian Raffles, a friend of the author (Plate 41). Naomi Mitchison was already nearly ninety and Elizabeth recalls the fascination of drawing the complex wrinkles of her face. The portrait was bought by the National Portrait Gallery in London. The success of these two portraits was followed in 1994 by a commission from Edinburgh University, her *alma mater* that had recently awarded her an honorary doctorate, to paint its retiring Principal, Sir David Smith, a congenial task not only for its association, but because Sir David is a distinguished botanist and she painted him with examples of the lichen he studied spread out on his desk (Plate 42). Although Elizabeth has not painted other portraits since then she has continued to produce figure paintings such as a series of a troupe of Japanese musicians who performed at the Queen's Hall in Edinburgh in 1988 (Plate 43).

The Japanese experience gradually entered Elizabeth's painting in the late 1980s, and its full impact perhaps appeared to public view for the first time in a collection of works that she showed at the Mercury Gallery in 1991. It takes several forms. One feature of these pictures is her preoccupation with the wooden grids of the screens that the Japanese use all the time in their buildings. She plays with the layers of depth, the interplay of solid and void which is such a feature of this kind of architecture. But though she began to use it in a Japanese context here, this interest in grids goes right back to the beginning of her mature work, demonstrating the deep consistency in the way it has evolved. Back in 1961, for instance, the small mesh of birdcages within the larger grid made by many box-like cages stacked on top of one another and the birds fluttering within the framework of this double grid had caught her eye in a Paris market and she used it to make a remarkable composition. In 1968 she had painted the view through an internal window in the house at Queen's Crescent where the composition is defined by the grid of the astragals.

41 *Lady Naomi Mitchison*
1988 Oil on canvas 40 x 40 in (102 x 102 cm)

42 *Sir David Smith*
1998 Oil on canvas 14 x 12 in (36 x 30 cm)

43 (facing page) *Japanese Flute (Shakuhachi) Player*
1988 Oil on canvas 14 x 12 in (36 x 30 cm)

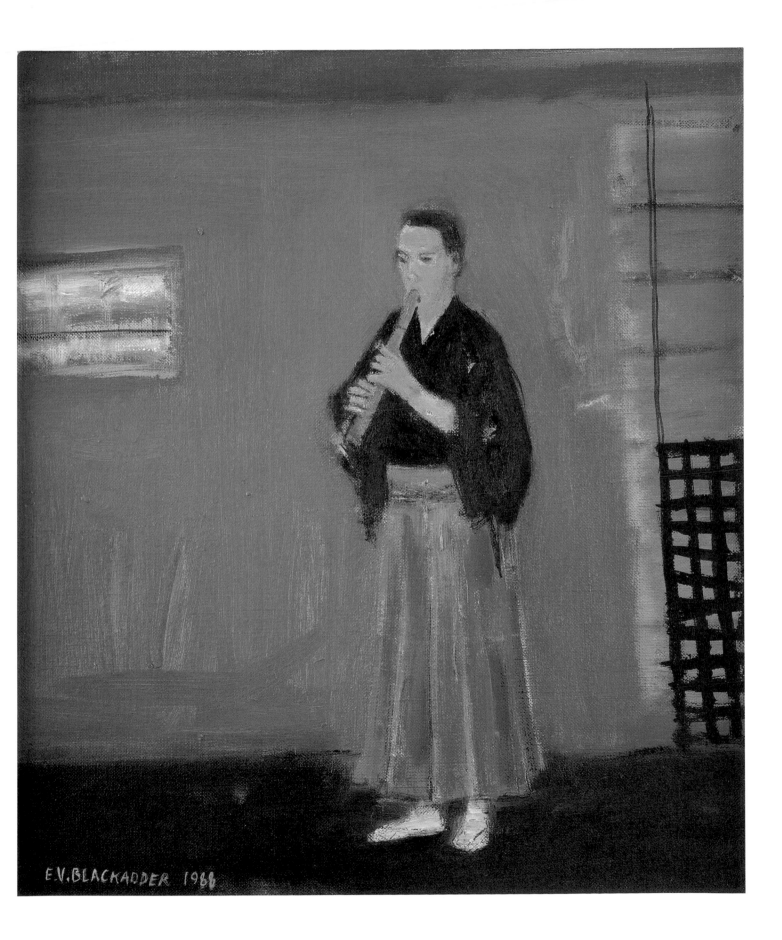
E.V.BLACKADDER 1988

44　*Little Still-Life, Akita*
1989　Watercolour　16¹/₄ x 20 in (41 x 51 cm)

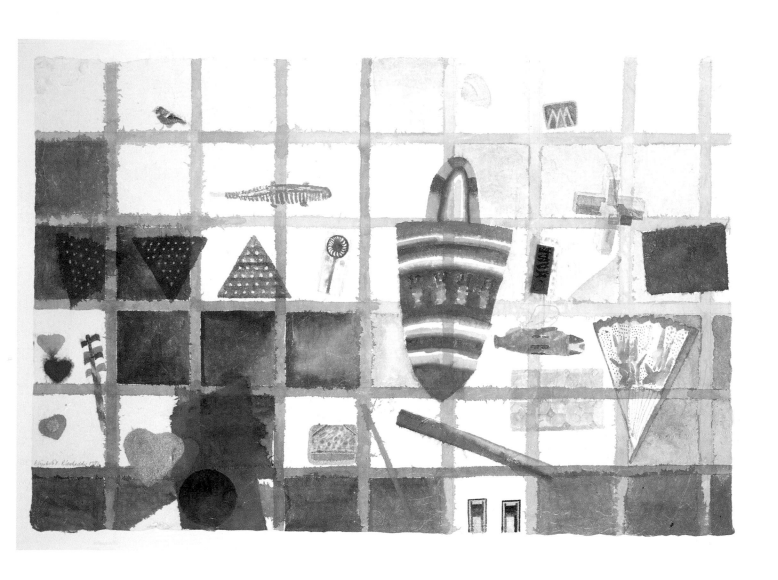

45 *Still-Life with Peruvian Hat*
1981 Watercolour 25¹/₂ x 37 in (65 x 94 cm)

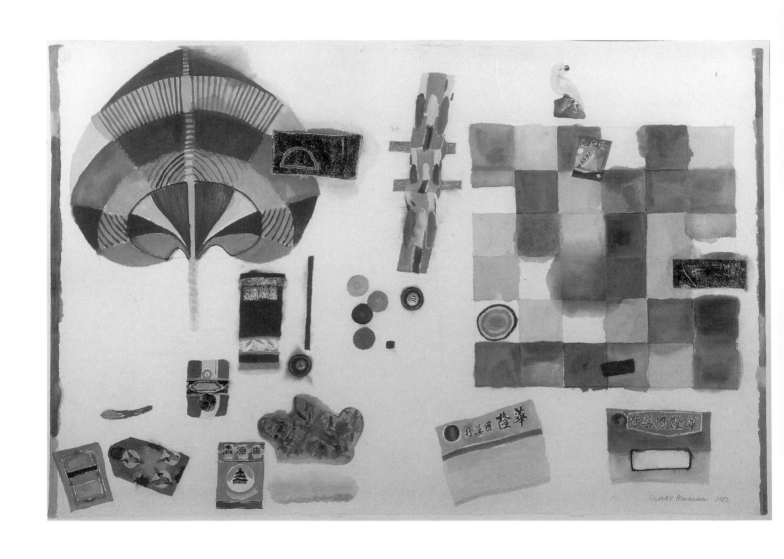

46 *Chinese Still-Life with Fan*
1982 Watercolour 24 x 35 in (61 x 89 cm)

Perhaps her earlier interest in Mondrian continues in these compositional concerns, though these pictures are far less austere than her still-lifes of the early 1970s. *Still-Life with Peruvian Hat* (1981, Plate 45) or *Chinese Still-Life with Fan* (1982, Plate 46), for instance, are nevertheless composed on a grid almost reminiscent of one of Mondrian's early grid pictures. Drawn in first in pencil in the former picture, this grid is then painted right across the picture in soft pink, its rigidity further softened by the feathered edge of watercolour on Japanese paper. Then the brightly coloured hat of the title appears to be hanging on this trellis. From the same year a watercolour on Japanese paper that Elizabeth particularly likes is *Still-Life with Agate*. It is a monochromatic picture, black and grey on buff paper. There is a white fan, a piece of black and white agate, a chequered box seen in perspective, a few touches of gold like the cloud shapes on a Japanese screen, but the dominant feature of the picture is a strongly drawn, asymmetrical and apparently entirely abstract black grid. Similar grids appear in various other pictures, too, a black and white one in *Japanese Still-Life* (1985). In one particularly grand example, *Gold Screen and Fans* (1991, Plate 47), the grid of a Japanese screen treated as an autonomous object fills the centre of the composition. Its squares are rendered in black and red and gold and it is half-framed in broad sheets of gold leaf that fill the top and the right-hand side of the picture.

A coloured chequerboard is another device she frequently uses, also a kind of grid. Sometimes it is explained in the title as a piece of cloth, or a board game. Sometimes Elizabeth reckons it is just an abstract device whose origins may go back to chess boards or other patterned elements in Indian miniatures, but the pictorial purpose of all these devices is to establish a surface that is clearly a plane but nevertheless also open. A grid is a tangible thing in the surface of the picture, but it does not shut off the pictorial world. It opens it up to us even while the plane it establishes shows that the picture is in fact a flat surface. It is a pictorial device that works just like a screen in fact, like the kind of space divider that is a constant feature of Japanese architecture, where space and structure are not mutually exclusive things, one enclosing the other as in classical Western architecture, but interpenetrate. It was this more than anything that Mackintosh learnt from his study of Japanese buildings, bringing as a result into Western architecture, at just the same moment that the same idea entered painting through Cubism, the understanding that space need not be static, the product of the separation of solid and void. It can be fluid, the product of their interpenetration, or an expression of their unity.

Maybe the artist is making a reference to this train of thought in her own art in two *Self-Portraits* that she painted around this time, *Self-Portrait with Cat* (1976, Plate 48) and *Self-Portrait with Irises and Cat* (1982). Both pictures are unusual in the genre in the way she has included the mirror, necessary tool of the painted self-portrait, as a prominent part of the composition. Seen straight on, in the same

47 *Gold Screen and Fans*
1991 Watercolour 38¹/₂ x 58 in (98 x 147 cm)

48 *Self-Portrait with Cat*
1976 Oil on canvas 43 x 49 in (109 x 125 cm)

plane as the painted surface, its strongly drawn frame clearly defines a picture within a picture. Indeed in the earlier of the two paintings there is very little that is outside the mirror, so the flat reflected surface becomes the whole composition. Within however, she herself is in profile so she cannot be looking at herself in the mirror, ironically turning the logic of this convention of the self-portrait on its head by making the mirror redundant and reminding us that the apparent space within is imaginary. At much the same date as this *Self-Portrait with Cat*, Elizabeth painted a little picture of a juggler who seems also to be a conjuror. He is perform-ing in front of a table covered with a cloth, but in a mirror behind it this appears to be a quite different cloth in a quite different configuration. Playing similar games, she is the conjuror in this self-portrait and in the later picture she plays similar tricks of illusionism. There a vase of irises stands between us and the mirror, but appears to have no reflection. In this picture, however, she is looking out in our direction, but on the wall behind her head there is a very abstract example of one of her Japanese paper still-lifes; making the link, it seems to consist of nothing but a grid.

In both paintings the Abyssinian cat looks out at us from within the mirror, sit-ting upright, alert, ears up, only its head visible. It is watching us, not looking at itself in the mirror and if it were, it is so close to the mirror that from our viewpoint we would have to see the back of its head from outside. It is curious about what is going on, and what is going on is the artist playing games, lightheartedly remind-ing us that she is conscious of what she is doing in her painting, that it is serious and complex, but also a source of delight. The cat is philosophical.

For Elizabeth Blackadder in her painting, as for Mackintosh in his architecture, the Japanese use of screens matches her understanding of picture space as we see it in these self-portraits. There is therefore no break at all between her still-lifes on Japanese paper and a series of paintings of Japanese buildings that she began in 1990 and exhibited in 1991 and that use the same techniques. In these pictures she even uses applied gold and silver leaf, but they and related oil paintings have as their subject traditional Japanese architecture, especially temples and shrines with their curving roofs, pillared doorways and extensive use of screens (Plates 49 and 50). *Large Shrine, Kyoto* (1991, Plate 51) is a beautiful example, as exquisite a picture as she ever painted, but also very grand. It is a watercolour on Japanese paper but more than four feet across. Most of the picture is taken up with the grids of several different screens. Behind these a dark interior is roughly brushed in. A dark roof is equally summarily indicated. Vertically across the centre, two columns of silver foil define an entrance and glimmer in the light. It is a wonderful study in imagina-tive, intuitive space, and of course as a painting of a sacred place, the invocation of the metaphysical dimension through this subtle beauty is part of the wonder. The painting is a particularly beautiful example of her ability to express spirituality in this way, but there are several others like it, such as *Red Shrine, Nara* (1995, Plate 52) in which the brilliant vermilion paint of Shinto shrines also adds a different note of vivid colour.

One feature of *Large Shrine, Kyoto* is the breadth and freedom with which it is

49 *Shrine, Kyoto*
1993 Watercolour 35 x 52 in (89 x 132 cm)

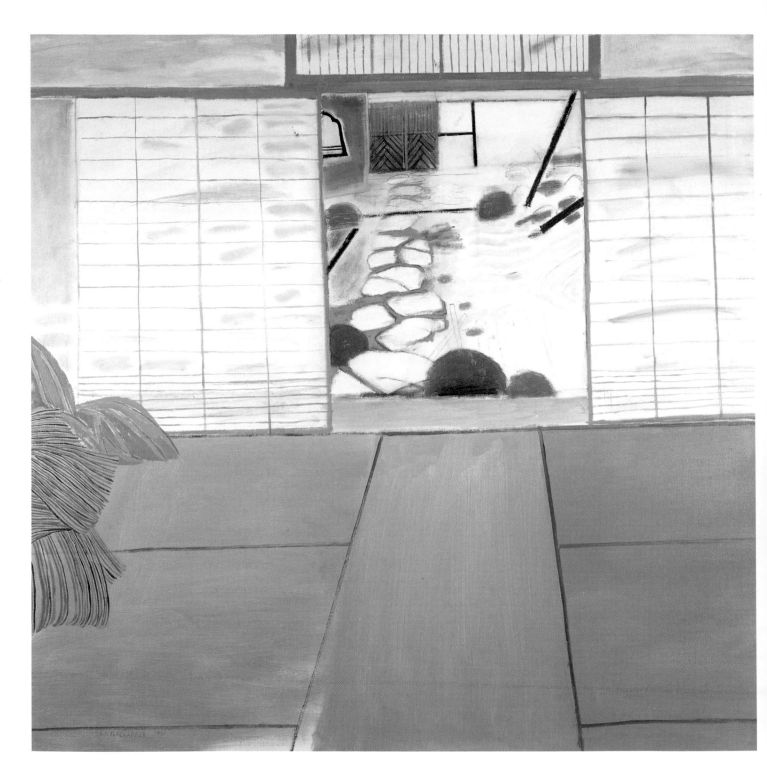

50 Interior, Kyoto, View of a Garden
1991 Oil on canvas 48 x 48 in (122 x 122 cm)

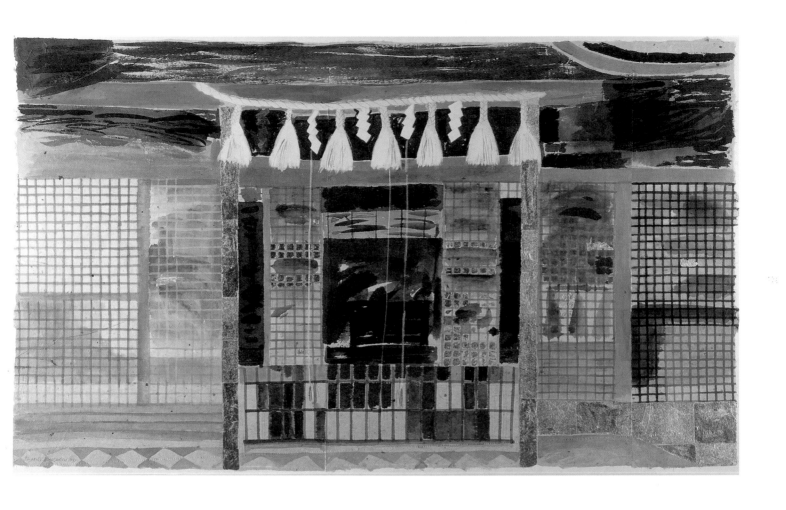

51 *Large Shrine, Kyoto*
1991 Watercolour 32 x 54 in (81 x 137 cm)

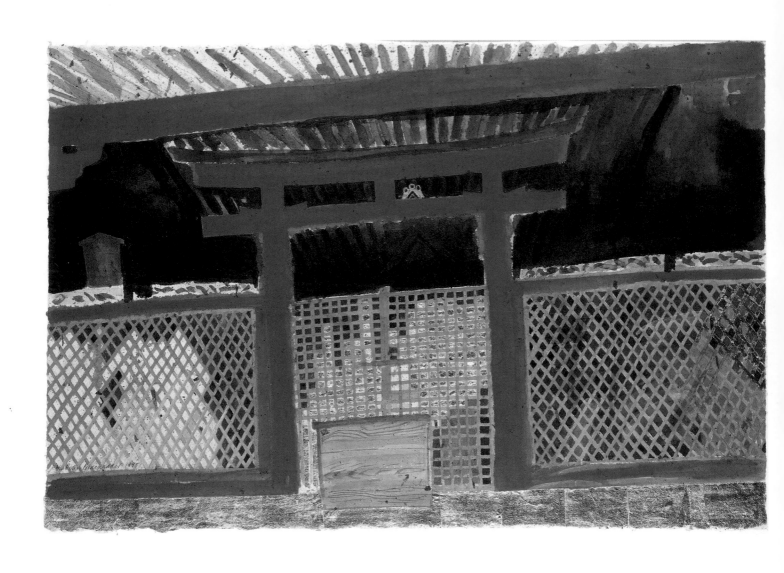

52 Red Shrine, Nara
1995 Watercolour 24¹/₂ x 37 in (62 x 94 cm)

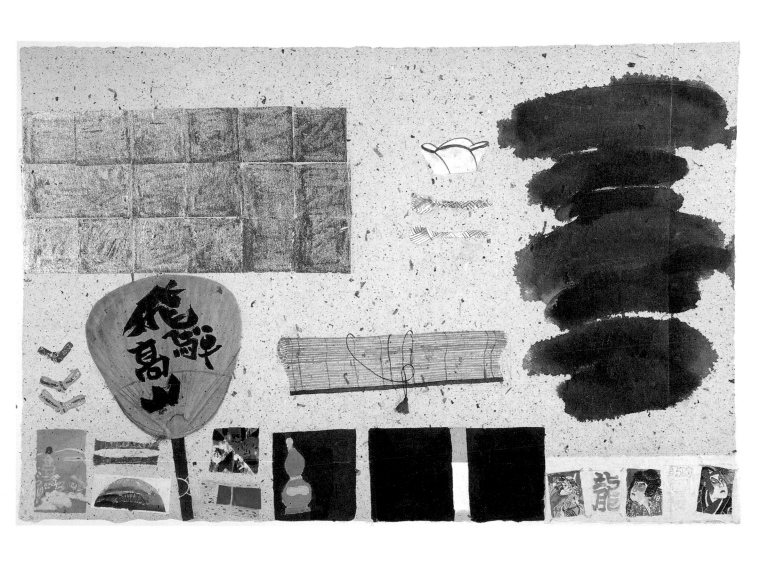

53 *Still-Life with Takayama Fan*
1994 Watercolour 28 x 42 in (71 x 107 cm)

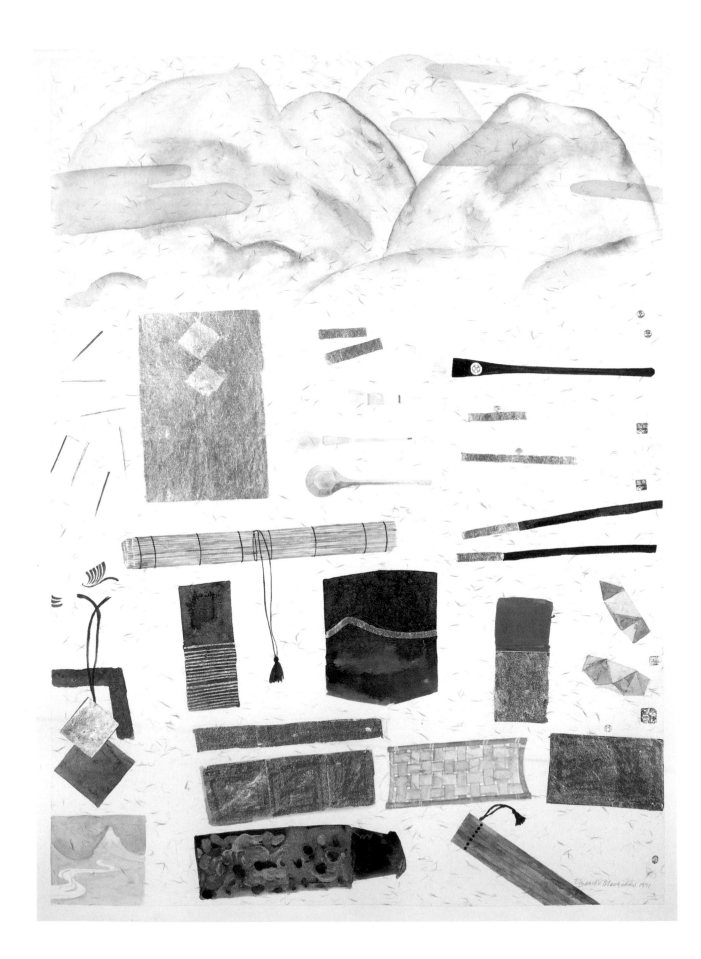

handled and frequently these later Japanese still-lifes have great black brush strokes in them that make dramatic cloud shapes, as in *Still-Life with Takayama Fan* (1994, Plate 53). In *Still-Life: Mountains in the Background* (1991, Plate 54) these become a landscape, but in *Still Life with Takayama Fan* the depth and movement of black ink is balanced by a sheet of burnished gold leaf made into a chequerboard by the pattern of fold lines still visible in its surface. In *Figures and Still-Life Kyoto* (1988) a fragment of diagonal trellis laid out in bold ink marks with feathered edges marches blackly across half the picture. Gold cloud shapes swim past beneath the trellis, and at the bottom of the picture this energy is contrasted with a delicate frieze of Ukiyo-e courtesans, the figures of the picture's title. Added to this freedom of handling, there is also increasingly vivid colour in some of these still-lifes. The picture that provided the poster for the Royal Academy show in 1990, for instance, was a Japanese still-life with purple irises, bright greens, a scarlet trellis, and a wash of bright red across the top.

. . . *A Return to Oil Painting* . . .

About this time the kind of complexity of perception in these watercolours also begins to appear in Elizabeth's oil paintings, and correspondingly they increase in scale. In the last decade she has painted more large pictures than in all the rest of her previous career. Somehow when it was the fashion to do so, she resisted the temptation to tackle huge canvases. Even now *Still-Life with Kimono* (1996) at six feet square is not enormous except compared to her earlier work. The increase in scale is clearly measured and is in response to a felt need that is internal to her painting, not some arbitrary ambition to fill a larger canvas. There is therefore a logic in this change and it is best seen in a series of fishpond paintings that are a very important feature of her work from 1990 onwards (Plate 55). These are a grand and summary statement of themes that had been evolving in her work over the years. For from the first of them it is clear that this shift in scale has to do with space and energy.

The first fishpond painting, *Koi Carp* was shown at the Royal Academy in 1990. It is a dramatic and powerful picture inspired by a fishpond that Elizabeth saw in the garden of the Glover House in Nagasaki. She was fascinated by the fishponds in Japan and describes how she could sit and gaze at them for hours. (There had always been a pond in the garden at Fountainhall Road. After their first Japanese visit the Houstons built a new and larger one, but they could never put fish in it. They tried but the herons ate them, and this is in spite of a large decoy heron that stands permanently on guard.) Other treatments of the subject since then include *Water-Lilies and Koi Carp* (1993, Plate 55), *Koi Carp, Ten Juan Nanzenji* exhibited in 1994 and *Dark Pool Alhambra* (1997, Plate 56). The latter is a beautiful painting of a fishpond at the Alhambra in Granada with golden lily leaves and slender red and black fish in dark green water, the result of a visit that John and Elizabeth made to Granada, Seville and Cordoba over New Year 1996-7.

54 (facing page)
*Still-Life:
Mountains in the Background*
1991 Watercolour
43 x 31 in (109 x 79 cm)

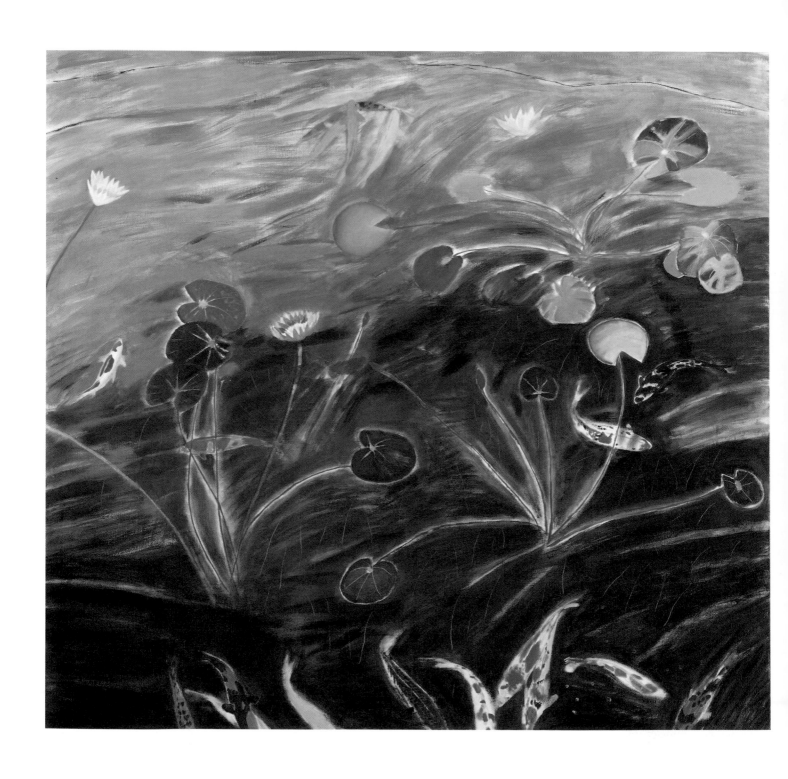

55 Water-Lilies and Koi Carp
1993 Oil on canvas 68 x 72 in (173 x 183 cm)

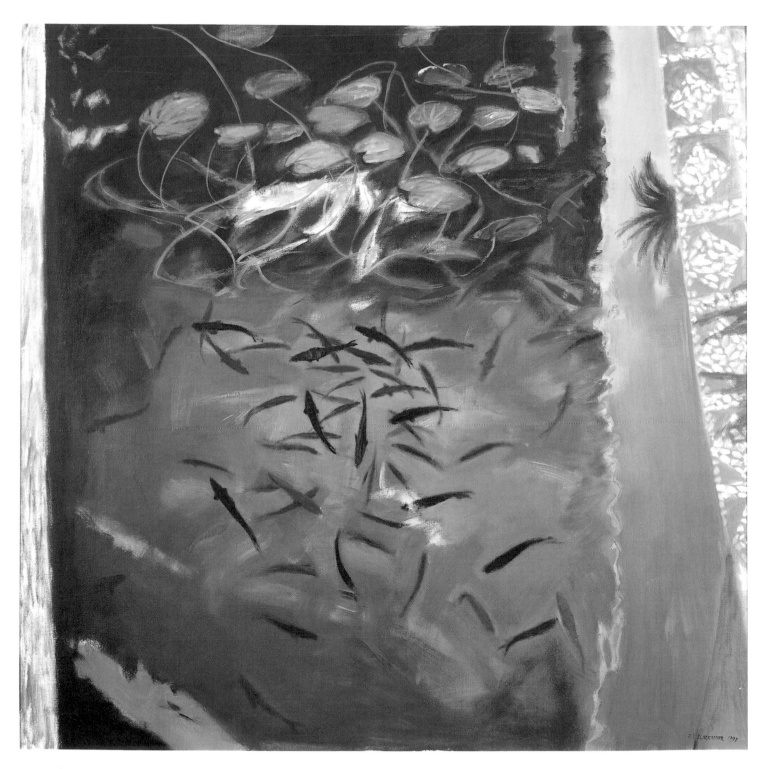

56 *Dark Pond, Alhambra, Granada*
1997 Oil on canvas 60 x 60 in (154 x 154 cm)

57 *The Forum, Rome*
1994 Oil on board, 8 x 10 in (20 x 25 cm)

You can see clearly how paintings like this relate to her still-life painting on Japanese paper, indeed more closely to it than to her landscape painting, though perhaps technically a fishpond is more landscape than still-life. Our viewpoint in these pictures is usually from directly above, so as they are in the same plane, it seems almost as though the surface of the picture has become the surface of the water. This effect is emphasised in the Nagasaki picture by two long stepping-stones that divide the canvas vertically just to left of centre. The fish are gathered against these at either side, heads inwards, tails waving, clusters of animated brilliance, living brushstrokes. And here it is important, too, that this is an oil painting, for instead of the contemplative calm of Elizabeth's watercolours on Japanese paper, the energy of the brush work and the materiality of the paint now give the picture a quite different character. We are looking at a living surface. In it the fish are both fact and metaphor. The painted surface of the water is active. It makes a kind of dynamic space.

In a way this visible brushwork takes on the role of the fibres in the paper in her Japanese still-lifes executed in watercolour, but here in oil paint is has physical, tactile energy given it by the movement of the artist's hand, and embodied in the fish. This points back to the way that Elizabeth is still after all a Western painter. A little painting of Roman ruins, *The Forum, Rome* (Plate 57), a site at the heart of the Western tradition, and another painting of a fishpond both of which she exhibited in 1994, seemed to me at the time to sum it up:

> Her use of scumbled paint in a broadly brushed open ground creates an imaginative space similar to the one that she achieves in the works in Japanese paper, but oil paint is much more active. It is a quintessentially Western medium. A beautiful little oil painting of Rome with its wonderful evocation of the solidity of the ancient brick and marble of its ruins is like an emblematic statement of this Western heritage. Like these Roman ruins, oil paint is concrete and tangible. It is on the surface, but it does not sit there passively. The colour is strong and vibrant and the marks of the brush suggest, not the eternally suspended gesture of oriental calligraphy, but the artist wrestling with the matter of experience. This is symbolised by the brilliantly coloured carp as they are painted swimming in their pools with the fluid brilliance of nature's brushmarks. The animation of these oriental fish is a reminder that even as she seduces us into the poetic beauty of an imaginary Orient, Elizabeth Blackadder is a Western painter. (The Scottish Gallery, 1994)

This little picture of the Roman Forum points out how the rest of her landscape painting was to follow what was already implicit in the fishpond pictures, for much of her landscape painting at the time was still in watercolour and in the relaxed direct mode that had characterised it all along as in *Oyster Boat and Dog, Loguivy* (Plate 58). A lovely watercolour of Honfleur from much the same date

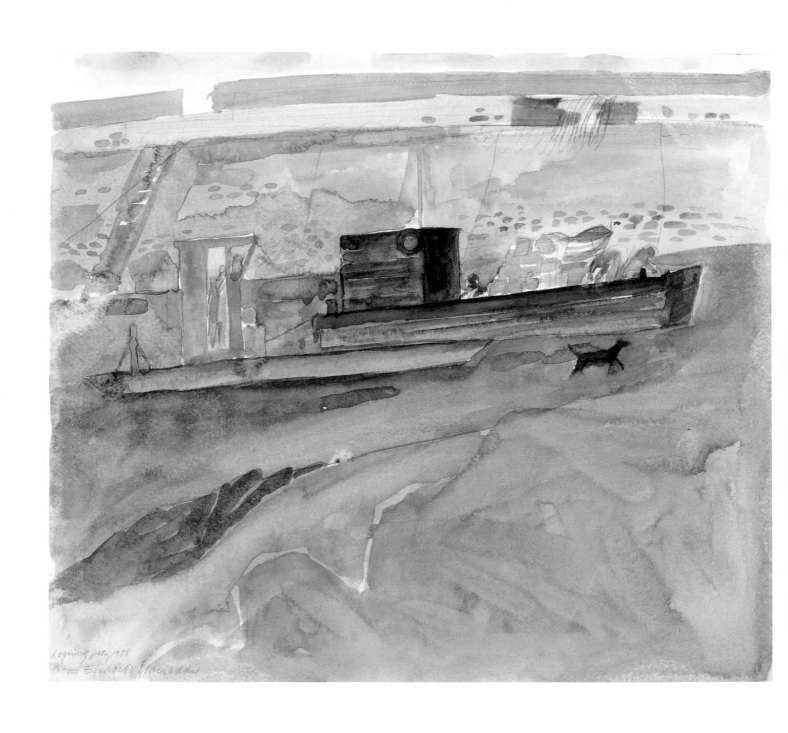

58 Oyster Boat and Dog, Loguivy
1988 Watercolour 13¹/4 x 15 in (34 x 38 cm)

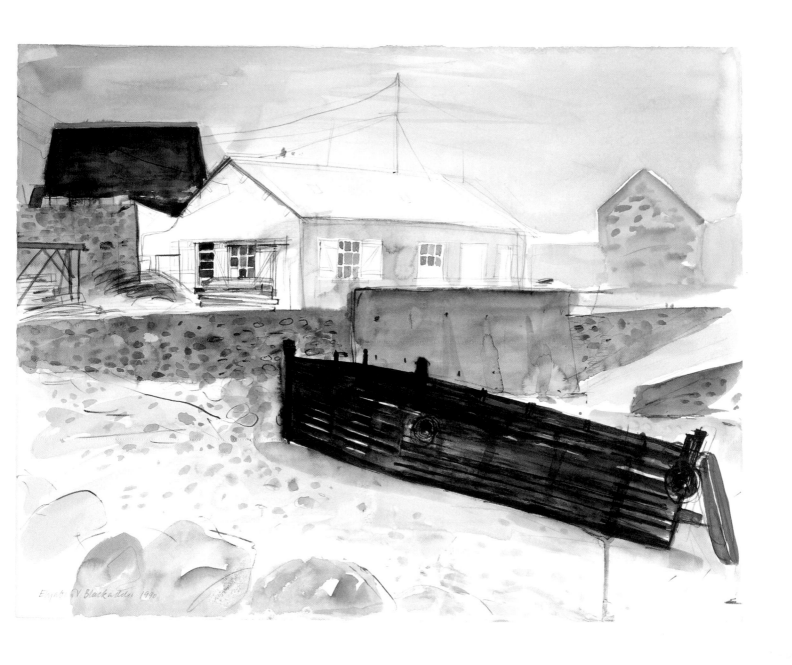

59 *Black Boat, Pors Even, Brittany*
1990 Watercolour 18 x 22^1/$_2$ in (46 x 57 cm)

60 *Still-Life with Cats*
1991-94 Oil on canvas 34 x 44 in (86 x 112 cm)

with boats tied up at a pier and a brilliant red mast dividing the composition, for instance, echoes the kind of compositional experiment that had characterised her still-life all along. But at the Mercury Gallery show in 1991 there were also several fresh and direct landscapes painted in France, a black boat tied up on a white beach at Pors Even in Brittany for instance, where though the confidence and command are absolute, she also still looks back to Gillies or William Wilson, reminding us as she does so that that is where her art is still rooted (Plate 59).

It is therefore the return of oil painting into the commanding position in her art that is the most striking feature of Elizabeth's recent work. It has led her to paint landscapes in oil on a scale that she had rarely done before, like *Buddhist Temple, Konchi-in, Kyoto*, for instance, a dramatic landscape painting of a temple which, at five feet square, is a large painting for her. But the aesthetic drive in these pictures still seems to come from her still-life painting. It set the pace and after all it has dominated her art for more than twenty years. In the same show in 1991 there were other pictures in which the new, energetic approach of the *Fish Pond* is strikingly apparent, but where this continuity with her still-life painting is equally clear. *Still-Life with Cats* (1991-94, Plate 60), for instance, takes up several familiar motifs. As the picture was first painted (and reproduced in the Scottish Gallery catalogue) there were only two cats. Now there are three. They sit with several still-life objects scattered across a table top, all summarily described. But the brush work runs across the picture with such energy, it is like a solar wind. One cat (it seems to be Coco) sits facing this flow of energy looking as though she is actually facing into a wind. The other is sitting with her back hunched against it as cats do.

As this freedom developed in her oil painting, so Elizabeth's watercolours also became more and more brilliant. Her Japanese paper still-lifes include fruit, flowers and vividly coloured fish alongside fans, ribbons and other objects that are equally brightly coloured (Plate 61). Pictures she exhibited at the Scottish Gallery in 1998 also included simple jewel-like paintings of a few objects, still-life subjects but freely painted as though there were no need of anything but the most elementary composition: *Tulips and Shells, Gladioli and Cornflowers, Asparagus and Artichokes* (Plate 62) or *Exotic Fish* (Plate 63). The intense saturated reds of tulips and gladioli, the deep purple of artichokes and tender pinks and yellows of asparagus, the iridescent red, blue and gold of fish and the translucent blue of mussels are all conveyed directly; self-sufficient they are set down as she has seen them. She also exhibited large flower paintings in oil for the first time on this occasion. She said, 'they just happened', but perhaps it was logical as the underlying concerns that have driven all her painting continued to mature and come into stronger focus. The thing that is striking about these new flower paintings, too, is their energy. Tulips spread their petals like dragon's wings. Daisy-like gerberas glow as orange as the setting sun. Strelitzia wave their bird-like flowers against a restless yellow ground – like the baroque, saw-tooth leaves of the exotic Australian banksia, these and much else are all recorded with vivid and manifest delight (Plate 64).

In these pictures the long stems of the flowers wander willfully across the canvas, the petals curl, all are driven by their own imperatives of growth and decay,

61 *Still-Life with Fruit*
1991 Watercolour 27³/4 x 41 in (70 x 104 cm)

62 *Asparagus and Artichokes*
1998 Oil on canvas 10 x 12 in (25 x 30 cm)

63 *Exotic Fish*
1998 Oil on canvas 24 x 26 in (61 x 66 cm)

64 *Still-Life with Banksia, Gladioli and Gerberas*
1998 Oil on canvas 40 x 44 in (102 x 112 cm)

65 *Self-Portrait with Red Lacquer Table*
1988 Oil on canvas 40 x 40 in (102 x 102 cm)

66 *Chinese Still-Life with Screen and Lotus Flowers*
1998 Watercolour 24¹/₂ x 39 in (62 x 99 cm)

not by the artist's controlling will. But little else is defined. Relationships seem casual, random even, composition accidental. A vase is not quite vertical, or a flower is cut off by the edge of the canvas. The coordinates of their own realities are autonomous, indifferent to the discipline of the frame. And these powerfully observed elements are all set against a lightly scumbled ground, neither flat nor solid, fluid even and with no overt clues by which to structure a space or deduce a location. Against this, objects are not composed. They drift, not aimlessly but on a kind of visible tide. The scumbled ground stands for both time and space. The relationships between objects are provided by our awareness of them within that continuum, but that continuum is not passive. It is dynamic. Our experience sets it in the shared field of consciousness of time and space that never stands still.

A few years earlier the artist had once again put herself in the picture in a beautiful self-portrait painted in 1988 (Plate 65). She is still self-effacing, this time in the Japanese manner, but also clearly self-aware. As in several earlier self-portrayals she teases us gently with a deceptively simple image. She is kneeling at the back of a Japanese room, wearing a black and white yukata, a Japanese sleeping robe. Perhaps a little ironically her pose is that of Japanese women at a traditional formal meal, kneeling in attendance, though the yukata, as a kind of nightdress, is not a formal garment. The composition is shaped by the three-dimensional grid of the walls and the pattern of tatami mats on the floor. But this grid is distinctly wobbly and any perspective certainty it might have achieved is overwhelmed by the brilliant red of a lacquer table which dominates the foreground but itself has little structure. It is as though any formal shape it may have had dissolved in the brilliance of its colour. A black lacquer box and a glass float against the red. Two black lacquer arm-rests intervene as ambiguous, unexplained curved shapes. In fact altogether it is a positive statement in which paradoxically nothing is certain. Even the artist's face and hair partly dissolve into the colour of the wall behind her. She sees herself in a brilliant, fluid world without fixed points.

We can see now more clearly than ever how in spite of formal differences the different modes of her painting are united by a common sensibility. Her still-lifes on Japanese paper illustrate this. Take *Chinese Still-Life with Screen and Lotus Flowers* (1998, Plate 66), *Shop Window, Kyoto* (1998, Plate 67) or *Still Life with Incense Sticks* for instance. As before exotic objects, little passages of gold or silver, elements of brush drawing, are all assembled together on a sheet of absorbent Japanese paper. There is no other narrative or spatial structure than their arrangement on the sheet and the way the paint sits in the paper, laid there in a single movement of the brush, or the gold and silver sit on its surface. But just as with the flower paintings, it is our shared awareness of the presence of the objects that creates the composition. They are placed mentally in the field of the imagination, not in any artificially structured space.

But in Elizabeth Blackadder's recent paintings of Venice this same vision has also evolved into a new kind of landscape painting, for this major series of oil painted landscapes is one of the most important new groups of work that she has done. The vision that informs them not only links them back to her still-life

67 *Shop Window, Kyoto*
1998 Watercolour 28 x 42 in (71 x 107 cm)

68 *The Dogana, Venice*
1998 Oil on canvas 12 x 14 in (30 x 36 cm)

painting, or beyond them even to her student work painted more than forty years earlier, it also places them squarely in the modern tradition. Several of these paintings are views across the mouth of the Grand Canal – it was the view from the room in the hotel where the Houstons were staying – to where the Dogana rides the waves like the prow of a great ship, its ancient architecture crowned by a fantastic golden weathercock. Palladio's church, the Zitelle, floats on the water beyond. It seems scarcely more solidly anchored than the boats that sail past. But for all that the views are familiar, in these paintings we are not offered the sparkling sunlight on water that is the usual image of Venice. Rather it is all in greys and greens and yellows, colours where sky and sea seem to share a common substance.

So it seems to be the fluidity of Venice, the constant movement of sky and water, rather than the fabled luminosity that most painters try to capture, that has fascinated Elizabeth. The boats chug past the Dogana (Plate 68) and, like the fish in the fishponds, they move in a moving medium. In Venice the water, the sky, even the architecture seems to move. The whole world is restless with constant movement. So it is not just what happens here in Venice that is her subject, but the whole flow of time and space in which we live.

All relationships are relative like this, and subject to constant revision. In painting, the equivalent to the conventional framework of narrative is ordered composition: the formal structures of space and depth and perspective. But the visible world is never really ordered into such a framework. We actually see it in random bits and pieces, strung together on the thread of our continuing consciousness. And in our consciousness whether what separates the elements of our experience is time or space – whether it is the spatial distance between objects or the temporal distance between events – these are actually so similar that they are interchangeable. Recognition that this is the true nature of experience has been one of the principal factors that has shaped modern art, distancing it from the structured formalities of the art of previous centuries. Cézanne saw this and set modern art on the course it has followed for a century. And so in this tradition, here in the Venetian paintings, as in all her art, Elizabeth Blackadder articulates and explores the universal condition of life through the intense and imaginative contemplation of local and particular experience. And what other kind of experience is there? Indeed it is because she focuses on the particular that she is able to touch the universal, and that places her squarely in the great tradition of Western painters.

. . . List of Plates . . .

1 *Church in Salonica*, 1954, Watercolour, 15 x 20 in (38 x 51cm), Private Collection

2 *Winter Landscape at Assisi*, 1955, Gouache and ink, 19½ x 29 in (50 x 74 cm), Private Collection

3 *Impruneta*, 1956, Pen and ink, 19½ x 29 in (50 x 74 cm), Private Collection

4 *Siena*, 1956, Pen and ink, 20 x 27 in (51 x 69 cm), Private Collection

5 *View of the Duomo, Siena*, 1955, Pastel, 18½ x 26 in (47 x 66 cm), Private Collection

6 *The Duomo, Florence*, 1955, Pen and ink, 13 x 18 in (33 x 46 cm), Private Collection

7 *Wall Town*, 1961, Oil on canvas, 34 x 44 in (85 x 111 cm), University of Edinburgh

8 *Still-Life with Turkish Coffee Mill*, 1964, Oil on canvas, 24 x 30 in (61 x 76 cm), Private Collection

9 *Façade, Mistra*, 1963, Watercolour, 27 x 31½ in (69 x 80 cm), Edinburgh City Art Centre

10 *Church in Brittany*, 1963, Oil on canvas, 30 x 40 in (76 x 102 cm), Private Collection

11 *Bathers, L'Esterel*, 1966, Oil on canvas, 39½ x 49 in (100 x 125 cm),
City of Aberdeen Art Gallery and Museums Collections

12 *Summer*, 1963, Oil on canvas, 40 x 50 in (102 x 127 cm), University of Stirling Art Collection

13 *Still-Life with Grey Table*, 1965, Oil on canvas, 40 x 50 in (102 x 127 cm), Collection of Artist

14 *Flowers on a Black Table*, 1968, Oil on canvas, 34 x 44 in (86 x 112 cm), Private Collection

15 *Still-Life with Japanese Flowers*, 1969, Oil on canvas, 44 x 56 in (112 x 142 cm), Government Art Collection

16 *Flowers and a Red Table*, 1969, Oil on canvas, 34 x 44 in (86 x 112 cm), Robert Fleming Holdings Ltd

17 *White Still-Life with Ribbons*, 1970, Oil on canvas, 50 x 54 in (127 x 137 cm), Private Collection

18 *Lilies*, 1966, Pen and ink, 24 x 22 in (61 x 56 cm), Private Collection

19 *Coco*, 1988, Pastel, 16¾ x 23¾ in (43 x 60 cm), Collection of Artist

20 *Studies of Cats*, 1996, Pastel, 20 x 26½ in (51 x 67 cm), Private Collection

21 *Studies of Cats*, 1994, Etching/Aquatint, 16 x 23 in (41 x 58 cm), Collection of Artist

22 *Black Cat*, 1980, Lithograph, 16 x 22 in (41 x 56 cm), Collection of Artist

23 *Cat and Flowers*, 1976, Watercolour, 22½ x 30 in (57 x 76 cm), Private Collection

24 *Cats and Flowers*, 1979-80, Lithograph, 23 x 31 in (58 x 79 cm), Collection of Artist

25a *Pages from a Sketchbook, Rosebay Willowherb and Red Campion*, 1970s, Pencil drawing, 5½ x 4½ in (14 x 11 cm),
Collection of Artist

b *Pages from a Sketchbook, Echium and Hydrangea*, 1970s, Watercolour, 5½ x 4½ in (14 x 11 cm), Collection of Artist

26 *Tulips*, 1998, Watercolour, 28 x 41 in (71 x 104 cm), Private Collection

27 *Shirley Poppies in a Jug*, 1983, Watercolour, 22 x 31 in (56 x 79 cm), Private Collection

28 *Anemones*, 1994, Watercolour, 22½ x 30 in (57 x 76 cm), Private Collection

29 *Blue and Purple Irises*, 1998, Watercolour, 30 x 20½ in (76 x 52 cm), Private Collection

30 *Strelitzia, Ginger and Passion Fruit*, 1996, Watercolour, 22 x 31 in (56 x 79 cm), Private Collection

31 *Orchid, Blue Vanda*, 1994, Watercolour, 30 x 22½ in (76 x 57 cm), Collection of Artist

32 *Beach, Elgol, Isle of Skye*, 1965, Watercolour, 27½ x 40 in (70 x 102 cm), Private Collection

33 *Peat Cuttings, Isle of Harris*, 1976, Watercolour, 26½ x 40½ in (67 x 103 cm), Private Collection

. . . List of Plates . . .

34 *Scalpay, Looking towards the Shiant Islands,* 1977, Oil on canvas, 36 x 40 in (91 x 102 cm), Collection of Artist

35 *Amaryllis and Crown Imperial,* 1979, Watercolour, 22¹/₂ x 31 in (57 x 79 cm), Collection of Artist

36 *Still-Life, Gold and White,* 1980, Watercolour, 27¹/₂ x 52 in (70 x 132 cm), Private Collection

37 *Still-Life with Flower Heads,* 1974, Watercolour, 24 x 35 in (61 x 89 cm), Private Collection

38 *Still-Life with Black Fish,* 1978, Watercolour, 23¹/₂ x 35¹/₂ in (59.5 x 90 cm), Bolton Museum and Art Gallery

39 *Still-Life Kurashiki,* 1985, Watercolour, 25¹/₂ x 58 in (65 x 147 cm), Collection of Artist

40 *Orchid Phalaenopsis – Antarctica,* 1992, Etching/Aquatint, 12 x 14 in (30 x 38 cm), Collection of Artist

41 *Lady Naomi Mitchison,* 1988, Oil on canvas, 40 x 40 in (102 x 102 cm), National Portrait Gallery, London

42 *Sir David Smith,* 1994, Oil on canvas, 48 x 44 in (122 x 112 cm), University of Edinburgh

43 *Japanese Flute (Shakuhachi) Player,* 1988, Oil on canvas, 14 x 12 in (36 x 30 cm), Private Collection

44 *Little Still-Life, Akita,* 1989, Watercolour, 16¹/₄ x 20 in (41 x 51 cm), Baring Asset Management Ltd

45 *Still-Life with Peruvian Hat,* 1981, Watercolour, 25¹/₂ x 37 in (65 x 94 cm), Private Collection

46 *Chinese Still-Life with Fan,* 1982, Watercolour, 24 x 35 in (61 x 89 cm), Private Collection

47 *Gold Screen and Fans,* 1991, Watercolour, 38¹/₂ x 58 in (98 x 147 cm), Private Collection

48 *Self-Portrait with Cat,* 1976, Oil on canvas, 43 x 49 in (109 x 125 cm), Diploma Collection, Royal Scottish Academy

49 *Shrine, Kyoto,* 1993, Watercolour, 35 x 52 in (89 x 132 cm), Private Collection

50 *Interior, Kyoto, View of a Garden,* 1991, Oil on canvas, 48 x 48 in (122 x 122 cm), Collection of Artist

51 *Large Shrine, Kyoto,* 1991, Watercolour, 32 x 54 in (81 x 137 cm), Collection of Artist

52 *Red Shrine, Nara,* 1995, Watercolour, 24¹/₂ x 37 in (62 x 94 cm), Private Collection

53 *Still-Life with Takayama Fan,* 1994, Watercolour, 28 x 42 in (71 x 107 cm), Private Collection

54 *Still-Life: Mountains in the Background,* 1991, Watercolour, 43 x 31 in (109 x 79 cm), Private Collection

55 *Water-Lilies and Koi Carp,* 1993, Oil on canvas, 68 x 72 in (173 x 183 cm), Glasgow Museums: Gallery of Modern Art

56 *Dark Pond, Alhambra, Granada,* 1997, Oil on canvas, 60 x 60 in (154 x 154 cm), Collection of Artist

57 *The Forum, Rome,* 1994, Oil on board, 8 x 10 in (20 x 25 cm), Collection of Artist

58 *Oyster Boat and Dog, Loguivy,* 1988, Watercolour, 13¹/₄ x 15 in (34 x 38 cm), Private Collection

59 *Black Boat, Pors Even, Brittany,* 1990, Watercolour, 18 x 22¹/₂ in (46 x 57 cm), Private Collection

60 *Still-Life with Cats,* 1991-94, Oil on canvas, 34 x 44 in (86 x 112 cm), Collection of Artist

61 *Still-Life with Fruit,* 1991, Watercolour, 27³/₄ x 41 in (70 x 104 cm), Private Collection

62 *Asparagus and Artichokes,* 1998, Oil on canvas, 10 x 12 in (25 x 30 cm), Private Collection

63 *Exotic Fish,* 1998, Oil on canvas, 24 x 26 in (61 x 66 cm), Private Collection

64 *Still-Life with Banksia, Gladioli and Gerberas,* 1998, Oil on canvas, 40 x 44 in (102 x 112 cm), Private Collection

65 *Self-Portrait with Red Lacquer Table,* 1988, Oil on canvas, 40 x 40 in (102 x 102 cm), Gillian Raffles, London

66 *Chinese Still-Life with Screen and Lotus Flowers,* 1998, Watercolour, 24¹/₂ x 39 in (62 x 99 cm), Private Collection

67 *Shop Window, Kyoto,* 1998, Watercolour, 28 x 42 in (71 x 107 cm), Private Collection

68 *The Dogana, Venice,* 1998, Oil on canvas, 12 x 14 in (30 x 36 cm), Private Collection

... Chronology ...

1931 24 September, born in her grandfather's house, Falkirk. Attended Strone Village School, Dunoon Grammar School and 1943-49 Falkirk High School

1949-54 studied for the joint Fine Art Degree at the University of Edinburgh and Edinburgh College of Art graduating with First Class Honours MA in Fine Art in 1954

1954 awarded Carnegie travelling scholarship by the Royal Scottish Academy and travelled to Italy, Greece and Yugoslavia

1954 awarded Andrew Grant Post-Graduate Scholarship by Edinburgh College of Art and spent the academic year 1954-5 as post-graduate at the College

1955-6 awarded Travelling Scholarship by Edinburgh College of Art, stayed in Italy from July 1955 till the following spring. The work she did in Italy was exhibited in the College on her return

1956 married John Houston and moved to London Street, Edinburgh. Appointed part-time teacher at Edinburgh College of Art for two years. Elected member of the Scottish Society of Artists

1958 travelled to Barcelona and Madrid

1958-9 teacher training course at Moray House, taught at St Thomas of Aquin's School and was then appointed librarian, Fine Art Department Library, University of Edinburgh. First solo exhibition, 57 Gallery, Edinburgh

1961 commission for lithograph, *Dark Hill, Fife,* from Museum of Modern Art, New York

1961 elected member of the Royal Scottish Society of Painters in Watercolour

1962 appointed full-time to teach at Edinburgh College of Art. Guthrie Award, Royal Scottish Academy. Commission for poster from GPO. Travelled to Greece

1963 elected Associate of Royal Scottish Academy. Moved to Queen's Crescent, Edinburgh. Travelled in France

1964 visited South of France

1965 visited South of France. First solo exhibition at Mercury Gallery, London

1966 visited Portugal

1967 tapestry commission for Scottish National Gallery of Modern Art. Visited Spain and Portugal

1968 visited Holland and Germany

1969 visited United States, painted at Racine, Lake Michigan

1971 elected Associate of Royal Academy. Visited Switzerland

1972 elected Academician of Royal Scottish Academy

1973 painted in Switzerland

1974 painted in the Isle of Harris

1975 moved to Fountainhall Road, Edinburgh

1977 visited Vienna

1979 commission for two lithographs from Mercury Gallery

1980 commission for tapestry from Edinburgh Tapestry Company. Painted in Normandy and Brittany

1981 retrospective exhibition, the Fruitmarket Gallery, Edinburgh

1982 awarded OBE. Visited Toronto and New York

1983 received Pimm's Award, Royal Academy. Visited New York and South of France

1984 commission for tapestry in two pieces from Reckitt and Colman. Visited Berlin. Elected member of the Royal Glasgow Institute

1985 visited Japan. Began etching at Glasgow Print Studio. Elected Honorary Member of the Royal West of England Academy

1986 retired from Edinburgh College of Art. Visited Japan. Elected Honorary Fellow Royal Incorporation of Architects of Scotland

1987 portrait of Molly Hunter commissioned by Scottish National Portrait Gallery, also painted portrait of Naomi Mitchison, purchased by National Portrait Gallery, London. Tapestries commissioned by Edinburgh Tapestry Company

1988 joint winner Watercolour Foundation Award, Royal Academy. Honorary Doctorate, D.Litt. Heriot Watt University

1989 window design commissioned by National Library of Scotland.

1990 Honorary Doctorate University of Edinburgh

1991 commission for tapestry from Scottish Provident

1992 elected Honorary Member of the Royal Watercolour Society. Visited Japan

1993 visited Japan

1994 elected Honorary Fellow of Royal Society of Edinburgh and also Honorary Member of the Royal Society of Painter Printmakers. Portrait of Sir David Smith commissioned by Edinburgh University

1995 visit to Penang to paint orchids. Stamp designs – cats – commissioned by Royal Mail

1997 Honorary Doctorate University of Aberdeen

1998 Honorary Doctorate University of Strathclyde

. . . Selected Bibliography . . .

WRITINGS BY THE ARTIST

Elizabeth Blackadder statement in Charlotte Parry-Crooke ed., *Contemporary British Artists*, London 1979
Elizabeth Blackadder, 'A world of infinite delight', *The Sunday Mail Story of Scotland*, part 48, Glasgow 1984
Elizabeth Blackadder with Dr Brinsley Burbidge, catalogue introduction *The Plant: Images of plants etc*, Scottish Arts Council, Edinburgh 1987

MONOGRAPHS

Judith Bumpus, *Elizabeth Blackadder*, Oxford 1988
Deborah Kellaway, *Favourite Flowers: watercolours by Elizabeth Blackadder*, London 1994, reprinted as *Irises and other Flowers: watercolours by Elizabeth Blackadder*, New York 1995

OTHER BOOKS

Edward Gage, *The Eye in the Wind*, London 1977
Jack Firth, *Scottish Watercolour Painting*, Edinburgh 1979
Harold Orel, Henry Snyder and Marilyn Stokstad eds, *The Scottish World*, New York 1981
Duncan Macmillan, *Scottish Art 1460-1990*, Edinburgh 1990
Charles McLean ed., *A Patron of Art*, The Royal Bank of Scotland, Edinburgh 1990
Bill Hare, *Contemporary Painting in Scotland*, Sydney 1992
Pierre Colonna d'Istria and Marie Leroy-Crevecoeur, *Dessins Contemporains*, Credit Lyonnais Foundation 1992
Judith Collins and Elsbeth Lindner, *Writing on the Wall: Women writers on women artists*, London 1993
Duncan Macmillan, *Scottish Art in the Twentieth Century*, Edinburgh 1994

MAGAZINES AND JOURNALS

T.Elder Dickson, 'Scottish Painting, the Modern Spirit', *Studio International*, December 1963
Douglas Hall, 'Elizabeth Blackadder', *Scottish Art Review*, IX 4 1964
Sydney Goodsir Smith, 'Drawings by Elizabeth Blackadder', *Connoisseur*, March 1965
Emilio Coia, 'Elizabeth Blackadder ARSA', *Scottish Field*, November 1966
Christopher Neve, 'Signs of life at Burlington House', *Country Life*, 9 May 1968
Anon. 'Views and News', *The Lady*, 29 July 1982
Philip Vann, 'RA Travel, Eastern Eden', *RA Magazine*, 15, 1987
Philip Vann, 'Elizabeth Blackadder: seeing things', *Artists' and Illustrators' Magazine*, February 1989

Linda Heywood, 'The Least Predictable Subject', *The Artist*, December 1989, pp29-31
Andrew Solomon, 'After Dinner Prints', *Harpers and Queen*, 1989?
Paddy Kitchen, 'Power of the Inanimate', *Country Life*, 30 May 1991
David Lee, 'Blackadder', *Arts Review*, July 1995

SELECTED NEWSPAPERS

'Young painters and sculptors', *The Times*, 1 September 1955
Sydney Goodsir Smith, 'Something for all', *The Scotsman*, 27 January 1962
Ion S. Munro, 'London looks at Scottish art', *Glasgow Herald*, 19 December 1963
Charles Greville, 'When marrying an artist means having a separate studio', *Scottish Daily Mail*, 4 February 1966
'Paintings which attract almost everyone', *Glasgow Herald*, 17 November 1966
Sarah Michel, 'Woman in art', *The East Fife Mail*, 19 May 1971
Terence Mullaly, 'Variety is theme of Academy summer show', *Daily Telegraph*, 28 April 1972
Edward Gage, 'Sense and Sensibility', *The Scotsman*, 19 June 1972
Alison Downie, 'From skyscapes to flower heads – a contrast in visions', *Glasgow Herald*, 27 December 1975
Irene McManus, 'Elizabeth Blackadder', *The Guardian*, 31 March 1981
Clare Henry, 'Major new show for Blackadder', *Glasgow Herald*, 10 July 1981
Edward Gage, 'Converting those heathen English', *The Scotsman*, 13 July 1981
William Packer, 'Scotland the Brave', *Financial Times*, 3 November 1981
Theodore F.Wolff, 'The many masks of modern art', *The Christian Science Monitor*, 1 December 1981
John Russell Taylor, *The Times*, 8 December 1981
Roderick Bisson, 'Artist who enjoys all she sees', *Daily Post*, 20 March 1982
Waldemar Januszczak, 'Outside London', *The Guardian*, 31 March 1982
John Russell Taylor, 'Communication of delight', *The Times*, 27 July 1982
'Galleries briefing', *The Guardian*, 28 July 1982
Terence Mullaly, 'The poetry, colour and intensity of Blackadder', *The Daily Telegraph*, late July 1982
William Packer, 'A bouquet for Blackadder', *The Financial Times*, 3 August 1982
Marina Vaizey, 'In the eye of the camera', *The Sunday Times*, August 1982

. . . Selected Bibliography . . .

Edward Gage, 'Memorable year for Blackadder', *The Scotsman*, 7 September 1982

Terence Mullaly, 'Lacking in flavour', *Daily Telegraph*, September 1982

Christopher Andreae, 'A watercolour dialogue', *Christian Science Monitor*, 8 March 1983

William Packer, 'Blackadder for the Tate', *The Financial Times*, 22 May 1984

Terence Mullaly, 'Poetical Elizabeth Blackadder', *Daily Telegraph*, 4 August 1984

Roger Berthoud, 'London Diary', *The Times*, 25 June 1985

William Packer, 'The middle ground', *The Financial Times*, 1 July 1985

Giles Auty, 'Festival overture', *Spectator*, 17 August 1985

William Packer, 'Themes and individuals', *The Financial Times*, 20 August 1985

Edward Gage, 'Woman's touch at the Mercury', *The Scotsman* Festival Supplement, 21 August 1985

Terence Mullaly, 'Two Scottish manners', *The Daily Telegraph*, 28 August 1985

Christopher Andreae, 'It was an orchid, now it is a Blackadder orchid', *Christian Science Monitor*, 1–7 February 1986

Vivien Rayner, *New York Times*, 18 April 1986

Clare Henry, 'Arts review', *Glasgow Herald*, 1 May 1987

Emilio Coia, 'Mayfest made manifest', *The Scotsman*, 4 May 1987

Alice Bain, 'Husband and wife drawn together for a double first', *Glasgow Herald*, 13 May 1987

William Packer, 'Age is opportunity no less than youth', *The Financial Times*, 1 November 1988

Catherine Lockerbie, 'A life of quiet inspiration', *The Scotsman*, 4 November 1988

Jack McLean, 'Blackadder quietly joins the famous Scots', *Glasgow Herald*, 6 February 1989

Michael Wigan, 'The decorative splendour of tapestry', *The Scotsman*, 8 February 1989

Mary Rose Beaumont, 'Spatial and other relationships', *The Financial Times*, 4 June 1991

Clare Henry, 'The Rise and Rise of the Scot', *The Herald*, 7 June 1991

Jim Bustard, 'Oriental Expertise', *The Scotsman*, 10 June 1991

Christopher Andreae, 'Dangerous subjects for a serious painter', *Christian Science Monitor*, 1 July 1991

W.E. Johnson, 'Galleries', *The Northern Echo*, 26 June 1992

Christopher Andreae, 'London's Gallery Row Feels Economic Pinch', *Christian Science Monitor*, 8 December 1992

Clare Henry, 'Burgeoning in spring', *The Herald*, 30 April 1993

W. Gordon Smith, 'Feast your eyes', *Scotland on Sunday*, 2 May 1993

Diana Hope, 'My personal choice', *The Scotsman*, 6 December 1993

'Tibbie Shiel's Diary', *The Scotsman*, 22 January 1994

William Packer, 'Talented but unfashionable', *The Financial Times*, 22 October 1996

Christopher Andreae, 'Crossing Cultures: one Painter's Attentive Eye', *Christian Science Monitor*, 20 December 1996

Duncan Macmillan, 'Etching to make an impression', *The Scotsman*, 9 February 1998

Clare Henry, 'The jewel in our crown', *The Herald*, 12 February 1998

William Packer, 'Notorious in their own time', *The Financial Times*, 16 May 1998

SOLO EXHIBITION CATALOGUES

Elizabeth Blackadder New Paintings, Mercury Gallery, nd. [1967?]

Elizabeth Blackadder, Lane Gallery, Bradford 1968

Elizabeth Blackadder, New Paintings, Mercury Gallery, October–November 1969

Elizabeth Blackadder, Vaccarino, Florence 1970

Elizabeth Blackadder Watercolours, Mercury Gallery, London 1971

Elizabeth Blackadder, Mercury Gallery, London 1976

Elizabeth Blackadder, The Scottish Gallery, Edinburgh 1976

Elizabeth Blackadder Exhibition, Middlesbrough Art Gallery, 1977

Elizabeth Blackadder, Mercury Gallery, London 1978

Elizabeth Blackadder, Mercury Gallery, London 1980

Elizabeth Blackadder; Retrospective, text by William Packer, Fruitmarket Gallery, Edinburgh 1981

Elizabeth Blackadder, Mercury Gallery, London and Edinburgh 1982

Elizabeth Blackadder Recent Watercolours, Theo Waddington, Toronto 1982

Elizabeth Blackadder: Henry Moore, Lillian Heidenberg Gallery, New York April–May 1983

Elizabeth Blackadder, text by William Packer, Mercury Gallery, Edinburgh 1985

Elizabeth Blackadder: Henry Moore, Lillian Heidenberg Gallery, New York 1986

Elizabeth Blackadder and John Houston, text by William Packer, Glasgow Print Studio 1987

. . . *Selected Bibliography* . . .

Elizabeth Blackadder, Mercury Gallery, London 1988
Elizabeth Blackadder, texts by Gillian Raffles and William Packer, Aberystwyth Arts Centre 1989
Elizabeth Blackadder, text by Cordelia Oliver, Mercury Gallery, London 1991
Elizabeth Blackadder Retrospective, D.L.I. Museum, Durham 1992
Elizabeth Blackadder, Orchids and other flowers, text by Stuart Duffin, introduction by the artist, Glasgow Print Studio 1993
Elizabeth Blackadder, New work, Mercury Gallery, London September–October 1993
Elizabeth Blackadder, text by Duncan Macmillan, The Scottish Gallery, Edinburgh 1994
Elizabeth Blackadder, New Oils and Watercolours, text by Christopher Andreae, Mercury Gallery, London 1996
Elizabeth Blackadder, text by Duncan Macmillan, The Scottish Gallery, Edinburgh 1998

SELECTED GROUP EXHIBITION CATALOGUES

International Prints, Auckland City Art Gallery, New Zealand 1961
International Prints, Cincinnati Art Museum 1962
Contemporary Scottish Art, Reading Museum and Art Gallery c1962
14 Scottish Painters, The Commonwealth Institute, London 1963
Twentieth-Century Scottish Painting, text by Douglas Hall, Abbot Hall Gallery, Kendal 1963
Spring Exhibition, Bradford City Art Gallery 1964
Contemporary Scottish Painters, Glynn Vivian Gallery, Swansea 1965
Summer Exhibition, Mercury Gallery, London 1966
The Richard Demarco Gallery Inaugural Exhibition, Edinburgh 1966
Summer Exhibition, Mercury Gallery, London 1967
Three Centuries of Scottish Painting, texts by Basil Skinner, William Buchanan and Douglas Hall, National Gallery of Canada, Ottawa 1968
Summer Exhibition, Mercury Gallery, London 1969
The Edinburgh School, text by William Kininmonth PRSA, Edinburgh College of Art 1971
A Mansion of Many Chambers: Beauty and other works, text by David Brown, Arts Council of Great Britain 1971
The Stirling Gallery 1st Exhibition, Stirling, nd. [c1972]
Drawings and Paintings from Fife Collections, text by William Buchanan, Fife Regional Council c1973

Edinburgh Ten 30, text by Edward Gage, The Scottish Arts Council exhibition touring in Wales 1975
The Royal Scottish Academy 1926-1976, Edinburgh 1976
British Painting 1952-77, Royal Academy, London 1977
Painters in Parallel, text by Cordelia Oliver, Scottish Arts Council 1978
Edinburgh College of Art: School of Drawing and Painting, Kirkcaldy Museum and Art Gallery 1980
The British Art Show, ACGB touring exhibition 1980
Master Weavers, Tapestry from Dovecot Studios 1912-1980, Edinburgh 1980
Contemporary Art from Scotland, The Scottish Gallery Touring Exhibition 1981–1982
Six Leading Contemporary Scottish Painters, Graham Gallery, New York 1982
The Guinness Guide to British Art and Artists, Britain Salutes New York, New York 1983
Portraits on Paper, text by James Holloway, Scottish Arts Council Touring Exhibition 1984
Unique and Original, Glasgow Print Studio 1985
Radovi na Papiru Professora Edinburgh College of Art, Belgrade University, Belgrade 1986
The Flower Show, Stoke-on-Trent Museum and Art Gallery 1986
Still Lifes Objects and Flowers, Henley Festival 1987
5th Heidelberg Biennale of Graphic Art, 1988
The Scottish Show, texts by Duncan Macmillan and James Holloway, Glynn Vivian Gallery, Swansea 1988
Salute to Turner, Agnews, London 1989
Scottish Art Since 1900, text by Keith Hartley, Scottish National Gallery of Modern Art 1989
National Library of Scotland: the Causewayside Building, The Works of Art, nd. [c1989]
Brush to paper, Three centuries of British Watercolours from Aberdeen Art Gallery, text by Francina Irwin, Aberdeen Art Gallery 1991
Scottish Art in the 20th Century, text by Duncan Macmillan, Royal West of England Academy, Bristol 1991
Women's Art at New Hall, texts by Marina Warner and Griselda Pollock, New Hall, Cambridge 1992
The Line of Tradition, text by Mungo Campbell, National Galleries of Scotland 1993
Scottish Painters, Flowers East, London 1993
Celebration, text by Pamela Robertson, The Hunterian Art Gallery, University of Glasgow 1999
Scotland's Art, texts by Duncan Macmillan and Murdo MacDonald, Edinburgh City Art Centre 1999

. . . *Solo Exhibitions* . . .

1959 57 Gallery, Edinburgh
1961 The Scottish Gallery, Aitken Dott,
 Edinburgh
1965 Mercury Gallery, London
1966 The Scottish Gallery, Aitken Dott,
 Edinburgh
 Thames Gallery, Eton
1967 Mercury Gallery, London
1968 Reading Art Gallery and Museum
 Lane Art Gallery, Bradford
1969 Mercury Gallery, London
1970 Vaccarino Gallery, Florence
1971 Mercury Gallery, London
 Loomshop Gallery,
 Lower Largo, Fife
1972 The Scottish Gallery, Aitken Dott,
 Edinburgh
1973 Mercury Gallery, London
1974 The Scottish Gallery, Aitken Dott,
 Edinburgh Festival Exhibition
 Loomshop Gallery,
 Lower Largo, Fife
1976 Mercury Gallery, London
 Loomshop Gallery,
 Lower Largo, Fife
1977 Middlesborough Art Gallery and
 Museum
 Hambledon Gallery, Blandford,
 Dorset
 Stirling Gallery, Stirling
1978 Mercury Gallery, London
 Yehudi Menuhin School,
 Stoke D'Abernon
1980 Mercury Gallery, London
 Oban Art Society
1981 Loomshop Gallery,
 Lower Largo, Fife
 Bohun Gallery,
 Henley-on-Thames
1981-82 Scottish Arts Council
 Retrospective Touring Exhibition;
 Edinburgh, Sheffield, Aberdeen,
 Liverpool, Cardiff, London

1982 Mercury Gallery, London
 Mercury Gallery, Edinburgh
 Festival Exhibition
 Theo Waddington Gallery, Toronto,
 Canada
1983 Lillian Heidenberg Gallery,
 New York
1984 Mercury Gallery, London
1985 Mercury Gallery, Edinburgh
 Festival Exhibition
1986 Lillian Heidenberg Gallery,
 New York
1987 Henley-on-Thames Festival
 of Music and the Arts
 Salisbury Festival
 Glasgow Print Studio
1988 Mercury Gallery, London
1989 Welsh Arts Council Retrospective
 Touring Exhibition;
 Aberystwyth, Brighton, Bangor,
 Cardiff, Bath, Lancaster
1990 Abbot Hall, Kendal
1991 Mercury Gallery, London
1992 D.L.I. Museum, Durham
 Retrospective Exhibition
1993 Glasgow Print Studio, *Orchids and*
 other Flowers
 Mercury Gallery, London
1994 The Scottish Gallery, Aitken Dott,
 Edinburgh Festival Exhibition
1996 Mercury Gallery, London
1998 Glasgow Print Studio
1998 Mercury Gallery, London
1998 The Scottish Gallery, Aitken Dott,
 Edinburgh
1998-99 Glasgow Print Studio, touring
 Great Britain and Ireland

. . . *Selected Group Exhibitions* . . .

1961 *Contemporary Scottish Painting,*
 Toronto, Canada
1963/4 *Fourteen Scottish Painters,*
 Commonwealth Institute, London
1968 *Three Centuries of Scottish Painting,*
 National Gallery of Canada,
 Ottawa
1971 *The Edinburgh School,* Edinburgh
 College of Art
1975 *Edinburgh Ten 30,* Scottish Arts
 Council Exhibition touring Wales
1977 *British Paintings 1952-1977,*
 Royal Academy, London
1978 *Painters in Parallel,* Scottish Arts
 Council, Edinburgh College of Art
1979 *Scottish Paintings and Tapestries,*
 Offenburg, West Germany
1980 *The British Art Show,* Arts Council
 of Great Britain touring exhibition
 *Master Weavers, Dovecot Studios'
 Tapestries,* Scottish Arts Council,
 Edinburgh
1982 *Six Scottish Painters,* Graham
 Gallery, New York
1984 *Portraits on Paper,* Scottish Arts
 Council
1985 *One of a Kind,* Glasgow Print Studio
 Still-Life, Harris Museum, Preston
1986 *Dovecot Studios' Tapestries,* Tokyo
 2D/3D, Laing Art Gallery,
 Newcastle
 Scottish Landscapes, National
 Gallery of Brazil, Rio de Janeiro
 The Flower Show, Stoke-on-Trent
 Art Gallery, touring show
1988 *Scottish Collection,* Fine Art Society,
 London
 Dovecot Studios' Tapestries, touring
 Australia

The Scottish Show, Oriel 31, touring
 Wales
Flowers of Scotland, Fine Art
 Society, Glasgow
Woodcuts, Glasgow Print Studio
Scottish Art since 1900, Scottish
 National Gallery of Modern Art
Images of Paradise, Rainforest Fund
1989 *Within These Shores,* a selection of
 works from the Chantrey Bequest,
 Graves Art Gallery, Sheffield
1990 *Scottish Art since 1900,* Barbican
 Centre, London
 Dovecot Studios' Tapestries,
 Houston, Texas
 Scottish Monotypes, Glasgow
 Print Studio
 Scottish Printmakers, Berlin
 Scottish Artists touring exhibition,
 Japan
 Salute to Turner, National Trust,
 London
1991 Glasgow Print Studio Exhibition,
 Moscow
 *Brush to Paper, 3 Centuries of
 British Watercolours,* Aberdeen
 Art Gallery touring exhibition
1993 *Scottish Painters,* Flowers East
 Writing on the Wall, Tate Gallery,
 London
 The Line of Tradition, National
 Gallery of Scotland
1999 *Celebration,* Hunterian Art Gallery,
 University of Glasgow
 Scotland's Art, Edinburgh City
 Art Centre
 *Liberation and Tradition, Scottish Art
 1963-1975,* Aberdeen Art Gallery,
 McManus Gallery, Dundee

. . . *Works in Public Collections* . . .

Abbot Hall Art Gallery, Kendal
Aberdeen Art Gallery
Argyll County Council
Barclays Bank
Baring Brothers Investments
Bolton Museum and Art Gallery
Carlisle Museum and Art Gallery
Clydesdale Bank
Contemporary Art Society
Continental Bank, London
Diamond Trading Company
Doncaster Museum and Art Gallery
Dundee Museum and Art Gallery
Dunfermline, Carnegie Trust
Eastbourne, Towner Art Gallery
Edinburgh City Art Centre
Fife County Council
Glasgow Museums and Art Galleries
Government Art Collection
Grampian Television
Greater London Council
Heriot Watt University
Hove Museum and Art Gallery
Huddersfield Art Gallery
International Mineral and Chemical
 Corporation
Kirkcaldy Museum and Art Gallery
Marion Koogler McNay Art Museum,
 San Antonio, Texas

Middlesborough Art Gallery
Museum of Modern Art, New York
National Museum of Women in the Arts,
 Washington DC
National Portrait Gallery, London
Nottingham County Council
Nuffield Foundation
Paisley Art Gallery
Perth Museum and Art Gallery
Reading Museum and Art Gallery
Robert Fleming Holdings
Royal Bank of Scotland
Royal Edinburgh Hospital
Royal Scottish Academy, Edinburgh
Scottish Arts Council
Scottish National Gallery of Modern Art
Scottish National Portrait Gallery
Scottish Television
Sheffield, Graves Art Gallery
Tate Gallery, London
University of Cambridge, Kettle's Yard
University of Edinburgh
University of Glasgow, Hunterian Art
 Gallery
University of St Andrews
University of Stirling
West Riding County Museum
Wustum Museum, Racine, Wisconsin

. . . *Photographic Credits* . . .

Photography by J.W.J. Mackenzie,
 AIC Photographic Services, Antonia
Reeve Photography, Joe Rock and others.
John Houston took the two photographs
of the artist which are reproduced.
The author also gratefully acknowledges
the help of Gillian Raffles in providing
transparencies.

The author would like to acknowledge with gratitude the kind and generous help extended to him in the preparation of this book by the artist and her husband, John Houston.

Gladiolus
byzantinus

Gladiolus
byzantinus

Iris pseudacorus